IMAGES
of America

IRONWOOD, HURLEY,
AND THE GOGEBIC RANGE

Gogebic Range towns are nestled in a valley between two sets of hills. Settlements developed just north of the iron mines. On this map, varying shades of gray indicate the region's topography; darker shading represents steeper land. Iron deposits developed in the more southern of the two bands of hills. This southern range is known to geologists as the Gogebic, although the whole area around these settlements is commonly referred to as the Gogebic Range. The Trap Range, the northern of the two, does not have large quantities of iron. The bluffs just north of Gogebic towns provide the greatest vertical drop in the region and have become suitable locations for downhill skiing. (Topography derived from U.S. Geological Survey digital elevation model.)

On the cover: Miners pose for the camera at the Pabst Mine's G Shaft. (Courtesy Ironwood Area Historical Society.)

IMAGES
of America

IRONWOOD, HURLEY, AND THE GOGEBIC RANGE

Matthew Liesch
with the Ironwood Area Historical Society

ARCADIA
PUBLISHING

Copyright © 2006 by Matthew Liesch
ISBN 0-7385-4066-8

Published by Arcadia Publishing
Charleston SC, Chicago IL, Portsmouth NH, San Francisco CA

Printed in the United States of America

Library of Congress Catalog Card Number: 2006922114

For all general information contact Arcadia Publishing at:
Telephone 843-853-2070
Fax 843-853-0044
E-mail sales@arcadiapublishing.com
For customer service and orders:
Toll-Free 1-888-313-2665

Visit us on the Internet at www.arcadiapublishing.com

For Andrea

Contents

Acknowledgments — 6

Introduction — 7

1. The Rush to the Range — 11
2. Settlement and Transportation — 27
3. A Built Landscape — 45
4. Community and Social Life — 59
5. Mining — 79
6. Rural Transformation — 99
7. Recreation — 113

Epilogue — 125

Bibliography — 126

Acknowledgments

Many people and organizations helped make this book possible. I probably cannot list them all, but here goes.

First, the Ironwood Area Historical Society (IAHS) played an integral role in this book's production. A small percentage of sales will be donated to the IAHS. Most of the photographs came from the IAHS's archives within the restored train depot in downtown Ironwood. Other images were provided by the Iron County Historical Museum (ICHM) in Hurley, and the Library of Congress (LC). Photographs not otherwise credited are from my personal collection. Even though I have primarily benefited from archives in Ironwood and Hurley, I have tried to secure images from throughout the entire Gogebic Range, since the towns have much in common with each other.

On the Gogebic Range, I was assisted by Gary Harrington and Ray Maurin of the Ironwood Area Historical Society; Joe Carlson, formerly of the Ironwood Carnegie Library; and Bruce Cox, Gilbert Endrizzi, Kent Goeckermann, Paul Sturgul, Hank Morello, and volunteers at the Iron County Historical Society.

In Madison, I thank Bob Ostergren, Arne Alanen, Jim Knox, Eric Olmanson, Travis Tennessen, Kara Dempsey, Amanda Peterson, and Melanie McCalmont for their interest in my work. I thank Andrea Jacob and my parents for putting up with me while I obsessively tried to finish.

Portions of this book are based upon my master's thesis in historical geography at the University of Wisconsin–Madison. I appreciate the monetary support received from the Association of American Geographers Historical Geography Specialty Group in the form of the Historical Geography Master's Thesis Student Research Award. Michigan Technological University (MTU) in snowy Houghton supported my research by giving me a Copper Country Archives Travel Award, sponsored by Friends of the Van Pelt Library. I also thank Erik Nordberg and Julie Blair of MTU for their assistance and hospitality. Finally, history buffs Gary Harrington, Paul Sturgul, and Joe Carlson critiqued my manuscript.

INTRODUCTION

Lake Superior's shores have yielded vast amounts of minerals, from pre-Columbian copper deposits to present-day amethyst and gold mines in Ontario. These deposits occur in large swaths called ranges. Geographer Donald Meinig tells us that during the industrial revolution, the largest shift in the American iron and steel industry was the increasing dependence on ores from Lake Superior. Throughout the country, railroads were expanding and iron was being used more to support buildings. As the demand for iron increased, speculators sought to develop new mineral regions. During the late 1800s, this growing demand resulted in the development of the Menominee, Gogebic, Vermillion, and Mesabi Ranges. Of these ranges, the Gogebic experienced an unusually high amount of speculation.

Geologically, the Gogebic Range extends from Lake Gogebic, Michigan, westward through a small portion of Bayfield County, Wisconsin. In Wisconsin, the area was originally known as the Penokee, a misspelling of the Ojibwe word *Pewabic*. The term Gogebic stems from the discovery of ore on the Western Upper Peninsula, but the name soon came to encompass the Wisconsin side as well. On the far western end of the range, where mining was not commercially successful, the term Penokee remains common. Scientists and surveyors noticed iron ore in Wisconsin during the 1840s. In 1856, the Wisconsin and Lake Superior Railroad planned towns at Ironton (now Saxon Harbor) and Penokee Gap, the current site of Mellen. Financial problems prevented these town sites from developing during the 1850s. Copper explorations came and left during the 19th century, but no copper of commercial value was extracted.

The waters of the Gogebic Range generally drain to the northwest and empty into Lake Superior. They are not navigable, so the range required railroad lines for efficient transportation. Once iron ore interest grew, railroads built track there. The Milwaukee, Lakeshore, and Western Railroad reached the range around 1884, stimulating land speculation and a dramatic rise in property values. The Gogebic was widely perceived at that time as a region of optimism and hope. The range burst from relative obscurity into the arena of public attention in the mid- to late 1880s because of its rich deposits of ore suitable for processing under the Bessemer method.

The Gogebic garnered much attention during this time. The more frequently a place name is mentioned, generally the more prominent role it may acquire in social memory. During the Gogebic's mining boom, the name Gogebic became powerful enough to grace company names both on the range and off, examples of the latter being the Gogebic Mining Exchange in Chicago and the Gogebic Investment Company in far away Unionville, Connecticut. The name Gogebic clearly came to mean something to the general public.

Newspapers powerfully represented the Gogebic Range. For example, on Sunday, June 27, 1886, the Milwaukee-based *Yenowine's News* told tales of small investors from Milwaukee striking it rich on the range. It reported the following:

> Rev. A. A. Hoskins, who has been the pastor of a small south-side church at a salary of $500 a year, is selling stock and property for mining companies, and in this way has made probably $25,000 the past three months. He got his start by mortgaging his little house and lot, and investing his all in Gogebic. He resigned his pastorate some months ago, and is now a regular boomer. Two young men named Hayes left Madison a few years ago to practice law at Ashland. They nearly starved to death until they became interested in Gogebic. Only last week they were offered a cool million dollars for their interests in a mine.

The article does not mention any specific companies or mines; rather, it was one of many spreading the idea that small investors could get rich by investing in a geographical region. Through stories such as this, the Gogebic came to symbolize hope and optimism.

During the rush, downtown Milwaukee was abuzz with rumors of riches in the Northland. Several Milwaukee-based periodicals focused on promoting the Gogebic's development. Stock exchanges opened in Ashland and Milwaukee just to handle the burgeoning number of Gogebic stocks. In addition to iron, rumors swirled around the possibility of rich deposits of gold, silver, and copper. The short-lived *Gogebic Explorer* touted gold deposits, none of which turned out to be commercially viable.

In the spring of 1887, the speculative bubble burst. The initial Gogebic boom ultimately led to general disillusionment, followed by periods of cautious optimism. There was still ore to extract, but investors became wary of losing money. Investors' lowered confidence depressed stock prices, bankrupting legitimate mining companies as well. In order to survive, the best mines were consolidated within the largest and strongest companies. During the 1890s, the consolidation of mines and companies was led by people such as John Rockefeller and Andrew Carnegie.

The Gogebic has been a place of booms and busts stretching from 1884 to 1967. Population hopes and dreams on the range have fluctuated wildly over time as the mines have either prospered or been abandoned. Cities grew due to the mining speculation. By 1890, six years after settlement began, Ironwood and Hurley were home to more than 10,000 residents. Ironwood, Michigan, is the largest city on the Gogebic Range. The Montreal River cuts through the center of the range, dividing the two states. Just to the west of the boulder-strewn river is the city of Hurley, Wisconsin, the largest city on the Wisconsin side. Wakefield, Bessemer, and Montreal also grew. Many other settlements, known as mining locations, developed around mine sites. Economic opportunity lured immigrants to the range. Census data reveals that in 1910, 47 percent of the range's population had emigrated from Europe and Canada. Finns and Italians were the two largest ethnic groups. As the range developed, community organizations flourished, with social networks customarily divided along ethnic lines.

During the 1800s, newspapers issued grand statements about the future of their town, a process known as boosterism. Newspaper editors often gave fanciful reasons as to why their town was destined to become greater than other competing towns. Boosterism occurred throughout western North America, not just on the Gogebic Range. Here, newspapers in Hurley, Ironwood, Bessemer, and Wakefield each described their geographical situation as ideal for growth.

Governments became more elaborate over time. Gogebic County, Michigan, split off from Ontonagon County in 1887, owing in part to the difficulty of traveling to the county seat at the village of Ontonagon. On the Wisconsin side, population growth also brought a desire for local representation. In 1893, Iron County split off from Ashland and Oneida Counties. Power also came from the mining companies themselves. Decisions made at mining offices in Cleveland directly affected life on the Gogebic. For example, people sitting around a table at a corporate office in Cleveland, Ohio, could decide to close up Gogebic mines, hurting the range's economy. The mining landscapes shown in this book are, in large part, the result of actions in Cleveland, Milwaukee, or Chicago.

To more fully understand the Gogebic's history, we need to consider how places are connected with one another. The actual qualities of a place matter, but sometimes imagination is more powerful. A reputation can entice people or scare them away. For example, when people think of Las Vegas, they get an image in their heads of casinos and gambling. Las Vegas's present-day reputation lures some while discouraging others. During the late 1800s, the Gogebic's towns had a similarly strong reputation. Situated in the middle of the range, the small city of Hurley, Wisconsin, is unusually well known. Numerous writers have acknowledged Hurley's notoriety. In the words of Walter Havighurst, "From Saginaw to Duluth it was said, 'The four toughest places on earth are Cumberland, Hayward, Hurley and Hell.' And Hurley was second to none of them." Within the range, towns often accused each other of being places of sin. "The Ironwood *Times* gives Hurley a bad racket as being the headquarters for thugs, swindlers, and hard characters generally," complained the *Montreal River Miner* on December 2, 1886, before retorting that Hurley's problems came from Ironwood. Some of Hurley's reputation is earned, but a good deal of exaggeration existed. During the 1880s, the whole range had an unusually unsavory reputation, and editors of the Wakefield and Bessemer newspapers argued over whether it was undeserved or if the range should increase social control. The region's prominence as a tough place developed through nightlife and mining.

Many other features combined to make the Gogebic Range distinct, such as ethnic settlements, waterfalls, and rugged land. As a geographer, I am interested in places. I think the range has a distinct sense of place compared to much of the surrounding area. The term "Midwest" conjures thoughts of agriculture, open spaces with gently rolling hills, and forestry in the Northwoods. Being in the vicinity of Lake Superior, the Gogebic is perhaps peripheral to the conventional Midwest. The Gogebic and neighboring iron and copper ranges have a harsher climate, more rugged topography, and a more tumultuous economic life than stereotypical images of the Midwest would have us think.

As the Gogebic's mining economy withered away during the 1960s, many residents had to move away to find jobs. I am impressed with the attachment to the region felt by many former residents. The Gogebic's sense of place still beckons those who left for elsewhere, regardless of where they currently live. In some cases, former residents move back to the area to retire, even though Florida has much better weather. There is a strong contingent of onetime residents interested in the Gogebic's local history and genealogy. Other people return for heritage festivals. Through the photographs in this book, I hope to capture even a small portion of this affection for the place.

Rather than writing a conventional geography or history book, I use photographs to explore several themes important to the Gogebic Range. I selected photographs that exemplify the tremendous change on the Gogebic Range during its first few decades. Although I focus on the Gogebic's early days, numerous pictures from the mid-1900s showcase how the Gogebic has changed over time. Images in this book run from Copper Falls State Park on the west end through Wakefield to the east. Photographs are grouped according to theme with the understanding that most could belong to multiple themes. The Gogebic's formative years involved many strange juxtapositions; this book tries to highlight these curiosities, such as settlers eager to farm rocky, stump-filled land, weeds flourishing in front of grand hotels, Finns taking orders from Cornishmen, and so on. I focus on the Gogebic's early days, since the frontier era dramatically transformed the range. In the rush to discover "red gold," wooden buildings were hastily constructed, burned down in fires, and rebuilt with brownstone. Raised wooden plank sidewalks were constructed only to have miners' boots cover the wood planks with a thin film of reddish iron ore dust. Fancy hotels sprang up where pines grew.

I emphasize landscapes, both beautiful and ugly. By showing historic landscapes, I hope to capture the Gogebic's sense of place. The scenery has stories to tell, for clues on the land reveal many of the ways in which humans and the environment have shaped each other.

<div style="text-align: right;">
Matthew Liesch

June 2006
</div>

One

THE RUSH TO THE RANGE

On September 16, 1886, the *Chicago Tribune* proclaimed the following:

> Hundreds of people are arriving daily from all parts of the country and millionaires are being made by the dozens. . . . The forests have given way to mining camps and towns, and a most bewildering transformation has taken place. In the palmy days of gold mining on the Pacific slope there is no record of anything so wonderful as the Gogebic.

The *Chicago Tribune*, like many newspapers across the lower Great Lakes, sought to portray the Gogebic Range as a geographic region of hope and fortune, ripe for immediate investment. For many potential investors living in cities such as Milwaukee, Chicago, and Cleveland, articles such as these constituted the primary source of geographical information about the booming range. Still, other newspaper reports reveal that many corporate founders tried selling stocks to people in their locality. These are just the legitimate ventures. Many more were off the books. Bad stocks were abound, and as time went on, rumors began to circulate about mining scams. Many companies never filed official papers. There is no way of knowing just how many stock offerings existed at the peak of the mining boom during early 1887.

The Gogebic Range was viewed as a place of investment opportunity for millions living across the lower Great Lakes region and farther to the east. Representations of the mining economy were essential in luring investors. Many invested blindly, taken in by rumor and speculation, and lost money. Some invested in poorly managed mines; others thought they were investing in mines but had actually fallen into scams. In the aftermath of the boom, investors were cautious elsewhere, and the region was regarded as a place of corruption and despair. Of course, there was still lots of ore to be mined, but this chapter focuses on the Gogebic's early days, particularly how this new region was promoted.

This is a portion of a map printed with the purpose of advocating a railroad expansion from Wisconsin's Fox Valley toward Ontonagon and Copper Harbor. These Ontonagon citizens had, in 1853, advocated for a spur to be built paralleling the present-day Gogebic. Of course, "Gogebic" is not labeled, but the map shows "iron" where the Gogebic would be developed about 30 years later. (Courtesy LC.)

The actual locations of ore deposits were highly debated. Commercially viable ore bodies could be found beneath the central Gogebic. But where else? On this 1853 map, the "South Range" is almost as far eastward as the Marquette Range. Over 30 years after this map was drawn, some investors still figured that the Gogebic Range extended as far eastward as Lake Gogebic; others claimed that it was a westward extension of the Menominee and Marquette Ranges. Since this map was used to promote railroad development, the creators had incentive to exaggerate the size of ore deposits. The flyer mentions, "At other points several varieties of iron ore have been found, showing that the mineral extends from the Carp River westwardly into the State of Wisconsin." (Courtesy LC.)

The Colby Mine was the first on the Gogebic to ship ore. The Colby initially developed as an open pit; as the pit became deeper, the company's first two shafts could be entered through a horizontal shaft known as an adit. Six years after opening, the Colby was shipping more tons of Bessemer-grade ore per year than any other mine in the country. Low in phosphorous, the quality ores of the range were well-suited for the Bessemer process of iron refining, which was the most efficient way of making high-grade steel during the 1880s: Bessemer steel production had reached four million tons by 1890. In 1892, eight years after the Colby's first shipment, the Gogebic was producing one-third of Lake Superior's iron ore. (Courtesy IAHS.)

The September 15, 1886, edition of the *Chicago Tribune* proclaimed, "The woods are full of prospectors and speculators. Shafts are being sunk on all sides, and there is no end to the possibilities of the country." This May 1886 view of an exploratory pit from the Puritan Mine is representative of early-to-mid-1880s Gogebic mine explorations. (Courtesy IAHS.)

During the earliest days of mining exploration, employees lived in tents until lodging could be built. Tucked away in the woods, hastily made shacks were erected to house miners, as seen in this May 1886 image. In the following years, boardinghouses would develop to house single miners. (Courtesy IAHS.)

In 1885, Hurley's Germania Mine became the first on the Wisconsin side to ship ore. Its immediate site was on fairly level ground atop a hillside overlooking town. The slope of the land is integral in deciding an optimal place for settlement. In the 19th century, many believed that disease was limited to certain kinds of environments. Settlements were situated, therefore, in what were deemed to be healthy spots. Gogebic promotional material featured both hillsides and valleys as excellent sites. Wetlands had negative connotations—not due to waterlogged soils, but because of the supposedly bad air. (Courtesy ICHM.)

From Watersmeet, the Milwaukee, Lake Shore, and Western Railroad intended to head north to Ontonagon on Lake Superior. Increasingly interested in the Gogebic, the railway decided to build track west instead. It had reason to promote Gogebic development, as it would naturally benefit from extra commerce. To make the Gogebic seem more impressive, the railroad's map distorts the Gogebic's territory to a larger size. In order to make room for seemingly long iron deposits, Ashland is pushed far west of where it should be. This map shows that the distance between Ashland and Hurley is twice as long as the distance between Ashland and Duluth, but in reality, the territory between Ashland and Duluth is much smaller. On professional maps, font size is roughly proportional to each city's population: when one looks at maps, it is assumed that the larger a font size, the more important a city is. But on this 1887 railroad map, several Gogebic towns show up in nearly the same size font as the metropolis of Chicago. For comparison, other large cities not on the train route have smaller font, such as Madison, Green Bay, and Racine. (Courtesy Miner and Manufacturer, June 1887.)

Wisconsin's Nimikon Mine is represented in an 1887 engraving. This art was common in newspapers during the Gogebic's frontier era. A few Milwaukee-based periodicals were devoted entirely to mining interests. While mining landscapes were the most frequently depicted Gogebic scenes, waterfalls and cities were also occasionally shown. Print media of the lower Great Lakes portrayed range optimism and cultural progress. (Courtesy Miner and Manufacturer and Gogebic News, October 1887.)

This 1886 advertisement for Moore, Benjamin and Company, based in downtown Milwaukee, uses a generalized cross-section of the Gogebic Range's geology in order to show it as a bountiful place. Within downtown Milwaukee, the five-story Mack Building, referred to here as the "Mack Block," was headquarters to several Gogebic mining companies. (Courtesy ICHM.)

The map above highlights the locations of investors starting mining companies on the Michigan side of the range through the end of 1887. It does not address those starting companies on the Wisconsin side, however, or the locations of later investors. Rather, the map indicates a pattern of investment running from Minneapolis eastward to New York City, with much coming from Milwaukee and small towns scattered throughout the western Great Lakes. Many investors lived in larger eastern financial centers such as Boston and New York before they became interested in Gogebic ore, but incorporation documents usually listed their mailing addresses as Milwaukee or Ashland. This data was derived from the Gogebic County Articles of Incorporation, MTU archives.

Newport miners were fortunate to reach high-grade ore; many other hopefuls had not. The well-known deposits of the Gogebic lay inside worn-down hills, with many of the towns located in a valley. To the north is the Keweenaw Trap Range, which stands in greater relief than the Gogebic itself. The Trap Range is commonly referred to as part of the Gogebic Range. As mining claims filled up the length of the Gogebic, rumors spread claiming that ore deposits were to be found along the higher and steeper bluffs just north of Gogebic towns. Although the area had been surveyed and dismissed by geologists, rumor was stronger than truth. This came in addition to speculation south of the Gogebic on the South Range, gold and silver speculation between Wakefield and Lake Gogebic, and of course, mostly unsuccessful explorations at the range's far western end. (Courtesy IAHS.)

Bessemer's Colby Mine was an open pit in early 1886. For every great mine such as the Colby, there were many more scams. Visitors to the range were less likely to make poor investments, although elaborate efforts might be made to fool those who came to check out operations personally. According to the February 13, 1887, *Milwaukee Sunday Telegraph*, Michigan's Gladstone Mine consisted of a small hole in the ground, and no ore. Knowing that potential investors were on their way to inspect the Gladstone, the owners bought five tons of ore from the nearby Anvil Mine and poured it down the shaft. To the unsuspecting, the Gladstone appeared to be full of ore. However, the scam failed because the ore was loosely piled in the hole, rather than forming along the shaft wall. (Courtesy IAHS.)

GOGEBIC MINING STOCKS

BOUGHT AND SOLD.

Safe and Profitable Investments. Reliable Information and Quotations furnished on Application. We represent nearly all the large Mining Companies on the Gogebic Range.

Address all Communications to

THE MILWAUKEE MINING EX HANGE,

TELEPHONE 1334. 85 WISCONSIN ST., MILWAUKEE.

John M. Stowell, Pres't. Ignatz Morawetz, Sec.
 Fred. Schleisinger, Vice-Pres't. A. B. Geilfuss, Treas.

MINES IN GOGEBIC RANGE.

SUMMIT MINING COMPANY.

Capital Stock, $1,000,000. 40,000 Shares, $25 each.

OFFICE: ROOM 15, MACK BLOCK,

MILWAUKEE, WIS.

John M. Stowell. Pres't. C. E. Sammond, Sec.
 Fred. Schleisinger, Vice Pres't. Walter Read, Treas

Mines on the Gogebic Range, near Wakefield, Mich.

IRONSIDES MINING COMPANY.

Capital Stock, $1,000,000. 40,000 Shares, $25 each.

ROOM 15, MACK BLOCK,

MILWAUKEE, - - WIS.

Shown here are typical advertisements from the *Miner and Manufacturer*, a Milwaukee-based mining newspaper. Large investors were able to visit the range, but smaller investors were less likely to have either the money or business acumen to inspect. On September 15, 1886, the *Chicago Tribune* warned its readers of the risks of investing in Gogebic scams: "Mines are stocked all the way from $500,000 to $5,000,000. . . . There are scores of embryo mining schemes, options, etc., and the country is fairly flooded with stock. Outsiders who do not know operators personally had better visit the range and see that there is really one as represented by the stock before purchasing." The October 22, 1887, edition of the same newspaper stated, "Hundreds of thousands of dollars were invested by Milwaukee and Wisconsin people in stocks that are not worth the paper on which they are printed." (Courtesy Miner and Manufacturer, April 16, 1887.)

Lake Agogebic Mining and
EXPLORING COMPANY,

Room 14, Library Building, 112 Wisconsin street, Milwaukee, Wis. Wm. Sanderson, president; C. A. Avery, secretary; T. S. Ilsley, treasurer. Capital stock, $1,000,000. Annual meeting first Thursday in June.

Little Colby Iron Mining Com-
PANY,

66 Wisconsin street, Milwaukee, Wis. H. M. Benjamin, president; H. Nunnemacher, vice-president; I. S. Klein, secretary and treasurer. Capital stock, $1,000,000. Annual meeting second Tuesday in January.

Milwaukee and Lake Superior
COPPER LAND COMPANY.

Office, Milwaukee. Fred. J. Johnson, president; C. S. Osborn, vice-president; W. W. Wight, treasurer; H. T. West, secretary. Capital stock, $24,000.

Mitchell Iron and Land Com-
PANY,

Ashland, Wis. Samuel Mitchell, president and treasurer; C. T. Bowen, secretary. Capital stock, $5,000,000. 5,170 acres in fee simple. Annual meeting first Tuesday in August.

Marenisco Mining Company,

Marenisco, Mich. Webb C. McConnell, president; A. A. Hammond, vice-president; John B. Weimer, secretary and treasurer. Capital stock, $1,000,000. Annual meeting second Tuesday in January.

Montreal River Iron Mining
COMPANY,

Cleveland, Ohio. J. H. Wade, Jr., president; E. W. Oglebay, secretary and treasurer. Capital stock, $500,000.

Metropolitan Iron and Land
COMPANY,

151 New Insurance Building, Milwaukee, Wis. S. S. Curry, president; H. S. Haselton, secretary; R. C. Hannah, treasurer; J. D. Day, superintendent. Annual meeting January 18.

Milwaukee Land and Iron

Prospect Hill Iron Mining Com-
PANY,

Room 11, Mack Block, Milwaukee, Wis. F. A. Bates, president; A. S. Upson, vice-president; H. S. Benjamin, secretary; C. F. Rand, treasurer. Capital stock, $1,000,000.

Planet Iron and Land Company,

Ashland, Wis. C. A. Sheffield, president; C. T. Bowen, secretary; G. W. Peek, secretary. Capital stock, $2,500,000, 2,400 acres in fee simple. Annual meeting first Monday in April.

Peerless Iron and Land Company,

Ashland, Wis. C. T. Bowen, president; W. D. Clark, treasurer. Capital stock, $2,500,000; 3,000 acres in fee simple. Annual meeting first Tuesday in August.

Richard Land and Iron Mining
COMPANY.

Milwaukee, Wis. Hugh Richard, president; W. A. Tracy, vice-president; W.H. Osborne, secretary; W. A. Richard, treasurer. Capital stock, $1,000,000.

Section 33 Iron Mining Company,

Ashland, Wis. Wm. Chrisholm, president; C. T. Bowen, secretary; Samuel Mitchell, treasurer. Capital stock, $500,000. Annual meeting first day in July.

St. Lawrence Exploring and Mining
COMPANY,

Manson, Marathon Co., Wis. Incorporators: Bernhard J. Pink, Chas. F. Crosby, W. L. Wheeler, Ernst Zimmerman, Geo. Stuhlfauth, J. J. Lohmar and R. J. Reed. Capital stock, $1,000,000.

Summit Mining Company,

Milwaukee, Wis. J. M. Stowell, president; Ferd. Schlesinger, vice-president; Ignatz Morawetz, secretary; A. B. Geilfuss, treasurer. Capital stock, $1,000,000. Annual meeting first Monday in December.

Superior Iron Mining Company,

Pfister building, Milwaukee, Wis. John Black, president; H. M. Benjamin, vice-president; John S. George, secretary and treasurer. Capital stock, $1,000,000. Annual meeting in January.

There are no means of determining exactly how many companies existed in 1887, though Chicago and Milwaukee newspapers claimed that there were almost 200 stock offerings during early 1887, with $200 million in capital. It did not take much to start an exploring company and offer stock, but much more capital was required to actually operate a mine. For example, Gogebic County incorporation papers reveal the Warrior Iron Mining Company's founders contributed no money; their only asset was the value of their 80 acres of land. Yet their stocks were issued at a listed value of $25 apiece. They had 40,000 shares on the market with a total "value" of $1 million. And this was a legitimate company that actually filled out the paperwork. Many scammers did not even bother with incorporation papers. (Courtesy Miner and Manufacturer, May 1887.)

Company Headquarters
- ○ = 1 office
- ● = 4 offices
- ● = 21 offices

By 1888, many companies were bankrupt. Mines require much more money than speculation, so there were less places where investors could pool their money to run mines and ship ore. Circles on the map are proportional to the amount of mines headquartered in a city. About 21 Milwaukee companies were actually operating mines in March 1888. Although most maintained an office at the mine to handle on-site affairs, real power was located at corporate headquarters. Decisions there impacted wages, living conditions, and mine safety. Businessmen in Milwaukee played a strong role in shaping the Gogebic's towns and landscapes. This data was derived from the 1888 Gogebic Range Business Directory.

This map shows the sites of companies still trying to sell stock in 1888. Compare this map to the previous one, which reveals the locations of actual companies from the same time. There are many more firms trying to sell stock than are actually mining. In 1888, companies from Minneapolis in the west through Cleveland in the east, and as far south as St. Louis, were organized to try and sell Gogebic stocks, but without any mines. This was after many poorly run mines had gone bankrupt. This data was derived from the 1888 Gogebic Range Business Directory.

LAKE GENEVA, APRIL 23, 1886.

GOGEBIC.

ITS UNBOUNDED WEALTH.

A Description of the Most Remarkable Iron Discovery of Modern Times.

Sketches of John E. Burton and Capt. N. D. Moore.

THE interest that our people have had, during the past year, in the Gogebic iron mining country, has intensified with time, rather than de-

Newspaper headlines such as this one from Lake Geneva, Wisconsin, were common during the Gogebic's boom years. How had lower Great Lakes newspapers been so wrong in their earlier portrayals of the region? There were three underlying factors. First, as papers picked up stories from other sources, enthusiasm spiraled upward through repetition. Second, investors paid reporters to write glowing accounts of the region's economic geography. "The *Chicago Times* has had a reporter up here writing up the range at $1 per line from business men, and a big contribution from some of the mining men," noted the *Montreal River Miner* in July 1886. Newspapers elsewhere were sometimes paid by the Gogebic's boosters to promote the region's image. Third, many editors had connections to mining investors, or owned stock themselves. The editor of southern Wisconsin's *Lake Geneva Herald*, responsible for the headline "Gogebic: Its Unbounded Wealth," was a business partner of John Burton. (Courtesy Lake Geneva Herald, April 23, 1886.)

Looking east in May 1886, this view shows the Aurora open-pit mine, which was partially owned by John Burton. The Gogebic's largest booster, Burton was a lightning rod for criticism. In the May 8, 1886, edition of the *Gogebic Iron Tribune*, Burton emphatically denied that a wild-cat mining scheme had ever been tried on the Gogebic. A chief investor in at least 11 mines, Burton would end up losing his money. By the summer of 1887, the *Wakefield Bulletin* had concluded soberly, "There is no disguising the fact that times are a little slow on the range just now, and that operations have been contracting somewhat along its entire length." Investor confidence plummeted, land prices dipped accordingly, and the boom was over. (Courtesy IAHS.)

Ironwood's Ashland Mine is seen from Hurley, looking east. The Montreal River appears in the foreground. At the Ashland Mine, explorations occurred in at least nine shafts between 1882 and 1926. Although the Ashland had work stoppages, it was one of the mines that survived the Gogebic's post-boom depressions of investor confidence. Off the range, naysayers leveled harsh criticism toward the Gogebic. In September 1887, the Two Harbors *Iron Port* bashed the Gogebic as corrupted by scandals: "The Gogebic Range has passed through her palmy days, and her reputation as an iron range nearly ruined by the many wild-cat, fraudulent mining companies, who so long in conjunction with the merciless mining sharks, have reigned supreme in that God-forsaken region." (Courtesy ICHM.)

Two

SETTLEMENT AND TRANSPORTATION

Railroads made the Gogebic's speculative boom possible. Without trains, large quantities of ore could not have been shipped to market. Most of the Gogebic's ore was sent by rail westward to Ashland, Wisconsin. From there, large freighters carried it to ports on Lake Erie. At various times, iron ore was also shipped from the Gogebic to Milwaukee and Chicago for processing. Although the ore was bulky, transporting pig iron was messy and even more costly. Refined iron added bulk to shipments, since lime and coal were used for smelting. By moving closer to the coal, transportation costs were kept as low as possible. Blast furnaces, needing both iron and coal, were located close to the general market, which was the industrializing Northeastern United States.

But to even extract ore, labor was needed. Railroads brought workers to the range. Mining ranges have distinctive settlement patterns. Around the mines, settlements known as mining locations grew. These communities oftentimes had their own churches, schools, and general stores. The Gogebic's largest towns developed just north of the mines, along the railroads.

Many more town sites were laid out or drawn by cartographers, but never developed. Amongst the locations that did develop, local identity was strong. Mining sites such as Jessieville, Reno, or Ramsay may not be well known outside the range, but are powerful to area residents. As the Gogebic Range grew, it attracted immigrant labor for the mines, particularly Finns and Italians. Given the gendered nature of mining labor, the early Gogebic Range had a very high ratio of men to women. Over time, though, this ratio would gradually equalize. Finnish miners, for example, occasionally placed advertisements back in Finland in the hope of attracting wives. Even well into the 20th century, these pleas for brides could still be found.

During the late 1800s, the Gogebic Range was known throughout the Great Lakes—both positively and negatively—for its mining speculation. Of course, this development brought many new residents. This chapter explores settlement and transportation during the Gogebic's early years.

The waters of the Gogebic generally drain to the northwest and empty into Lake Superior. They are not navigable, so the range required railroad lines for efficient transportation. Indeed, the development of the Milwaukee, Lake Shore, and Western Railroad served as a catalyst for the mining boom that drew public attention to the Gogebic. Each mine had its own spurs to move ore between mine sites and the main rail lines. These ore cars, shown on the tracks at the Norrie Mine, were built of wood and could hold 20 tons apiece. (Courtesy IAHS.)

A train crosses the state border along a rock cut on the Montreal River. At the close of the 19th century, several railroads were serving the range. (Courtesy LC.)

Looking to the west, this view shows the Chicago and Northwestern Railway crossing at Fourth Avenue in Hurley. The Twin City Iron Works is visible on the right side. (Courtesy ICHM.)

Silver Street in Hurley is pictured around 1885. The first building is the post office, followed by a restaurant. At first, Hurley served as the range's social center. Each range newspaper sought to situate its town atop the urban hierarchy. The April 3, 1886, edition of the *Montreal River Miner*, based in Hurley, claimed that its town was destined for greatness: "You may bet your last dollar on Hurley and you will win. Don't you forget it, Hurley is going to become to the [Gogebic] Range what Marquette and Ishpeming are to the old range." The article mentioned Hurley's first-class bank, its proximity to the Montreal River, and its central location on the range, which would be advantageous in terms of developing market areas, also known as hinterlands. According to the *Montreal River Miner*, "Hurley has everything requisite for the metropolis of Northern Wisconsin, and there is no doubt about its enjoying that prestige." (Courtesy ICHM.)

This photograph depicts the streetcar line at Cary Location in 1916. Streetcars facilitated easier access to the taverns of Silver Street, which meant that people from farther east and west could make an evening trip to Hurley. (Courtesy ICHM.)

Railroad companies built docks at Ashland, Wisconsin, to handle shipments of Gogebic ore. The long, tall ore docks were imposing features of the city's landscape. A couple were greater than a quarter-mile long. The eventual demise of the Gogebic mines meant that Ashland's economy was also hurt. Only one dock still stands today.

At the peak of the Gogebic's boom, shipping rates from Ashland were high. Some Gogebic ore was hauled by train to Escanaba, Milwaukee, and Chicago, but boats were cheaper than railroads. Since Gogebic ore had to be shipped west to Ashland before being sent eastward past the Gogebic on its way through Lake Superior to ports in Ohio, investors considered developing alternate ports from locations farther east than Ashland. Some plans would have taken advantage of the steep slopes downhill from the Gogebic and northward to Lake Superior, using gravity to haul the ore cars to the lake. This map just shows potential dock sites during the mid-1880s. In later decades, railroads were suspected of price-gouging. Some wealthy investors, such as Andrew Carnegie, considered developing ports on the coastline due north of the Gogebic. None of these alternate plans came to fruition. If Gogebic ore had been shipped from Saxon Harbor or Union Bay, for example, Ashland would have had a much different history.

The streetcar line originally ran between Gile, Hurley, Ironwood, and Jessieville. By 1915, the line reached Bessemer. Since its inception in 1890, the Gogebic's streetcar system had been operated by several different companies. What remained constant, however, was its wintry ordeal with the snow. Streetcars purchased in 1916 were too light to plow through the lake-effect snows. They were traded to Ashland, where storms were not as severe, for two heavier cars. Here, boys work on clearing snow from the tracks. Streetcars operated between 1890 and 1932. (Courtesy IAHS.)

Conductor Andrew Johnson is pictured on the streetcar track when the Twin City General Electric Company operated the line. This increased mobility amongst the range towns. At the time of this photograph, streetcars provided easy travel from Bessemer across the state border to Montreal. (Courtesy IAHS.)

32

Before automobiles, there was not much purpose in completely clearing roads when a horse-drawn sleigh could glide atop the snow. This scene depicts downtown Bessemer in 1902. (Courtesy ICHM.)

A man tries to ford swiftly moving water on the west branch of the Montreal River in 1917. Water rushes over the flooded road, which is present-day Wisconsin State Highway 77. The Gogebic floods areas farther to the south due to snow melt in springtime, as well as the shape of its watersheds. Steep stream gradients within long and narrow watersheds lead to faster discharge of water on the Gogebic compared to many other Midwestern places. In the north, increased clay in the soil also leads to less runoff absorption. These potentially hazardous geographical conditions make for roaring waterfalls in the springtime. (Courtesy ICHM.)

The small scale of the adults on both the left and right are a testament to the enormous size of this bridge damaged by rushing water. The collapsed bridge was a popular place for a photograph opportunity, as many similar images have been archived. Although this particular scene is on the Potato River at Upson in 1909, spans throughout the entire region have occasionally been damaged by floods. (Courtesy ICHM.)

The mouth of the Montreal River is strategically important. Taken at the beginning of the 20th century, this view looks north from above the first set of falls and toward Lake Superior. The Montreal River forms the border between Michigan and Wisconsin. Laden with canyons and waterfalls, the river is not navigable from Lake Superior. Between the 1600s and 1800s, and perhaps earlier, the French and Native Americans portaged southward to Lac du Flambeau, about 50 miles away. Everything had to be carried over the rugged hills to the Flambeau River watershed, navigable by canoe. This portage is commonly referred to as the Flambeau Trail. Visible in the upper left of this image, a narrow, horizontal strip is the only reasonably flat land around the lower Montreal, making it a suitable camping site for Native Americans and explorers alike. (Courtesy IAHS.)

Between Saxon Falls and Lake Superior, the Montreal River has canyons as high as 225 feet. Along these canyons, several mid-19th-century copper explorations failed. Since the early 1900s, two hydroelectric dams have changed the hydrology of the lower Montreal River. (Courtesy ICHM.)

For over a decade, Michigan and Wisconsin governments argued over the Montreal River. Northwest of Hurley, the river divides into two branches, the eastern one forming the boundary between the states. The west branch is about three miles farther west where it crosses the range. Michigan believed that original map makers had erred and that the Montreal River's west branch was the rightful boundary. As with countless other conflicts over territory, natural resources led the governments to fight; productive iron lands were beneath the soil. This argument went to the Supreme Court in 1920 and was settled without a change in 1923. (Courtesy IAHS.)

Archaeological reports reveal that during the early 1800s, John Jacob Astor's Northwest Fur Company had a trading post on the east bank of the Montreal River, adjacent to where the Flambeau Trail portage started. The Montreal River's mouth is described in the narratives of several explorers, such as Radisson and Groseilliers in 1661, Francois Malhiot in 1804, James Doty in 1820, and Henry Schoolcraft in 1820 and 1832. (Courtesy IAHS.)

This map shows the area around the mouth of the Presque Isle River before the founding of Porcupine Mountains State Park. The large numbers on the map indicate the sections within a township. During the 1800s, land surveyors divided Michigan and Wisconsin into towns of 36 square miles. Towns were further subdivided into sections of one square mile apiece. This system is commonly called the town and range system. This system is taken for granted now, but consider the Gogebic's boom years: during the mid-1800s, there were lawsuits over who rightfully owned which parcel of land. Without this systematic marking, even more controversy would have erupted over a particular piece of iron-rich land. (Courtesy IAHS.)

37

Frontier settlements caused profound changes in the Gogebic landscape. Settlers altered the land in a myriad of ways, from clear-cutting forests to introducing new varieties of plants. An 1899 photograph shows a wooden sidewalk with dandelions in front. In the modern era, dandelions are seen and are assumed that they have always been there. However, these weeds were brought to the Gogebic Range during settlement. When this photograph was taken, dandelions were a new sight. On the other hand, ragweed is native to the area but became much more common during the Gogebic's frontier era. (Courtesy IAHS.)

These children are on an elevated wooden sidewalk. The yard behind them shows no sign of landscaping. Tree stumps jut out of the ground to serve as reminders of previous landscapes. (Courtesy IAHS.)

Ironwood is pictured several years after its founding, during the early to mid-1890s. There is a difference in height between the sidewalk and the street. The building in the center bears a sign reading "Old Jake's Cabin." Tree stumps dot the landscape. Since the pines in this scene are missing lower branches, one can infer that area had previously been forest; when trees grow close together, their lower branches die off. (Courtesy IAHS, Wilbur Bridgman Collection.)

Cows sometimes wandered onto Silver Street in Hurley during the early to mid-1890s. Additional 19th-century photographs from elsewhere in the Midwest show that many cities occasionally had cattle in their roads. (Courtesy IAHS.)

The Cary Boardinghouse, seen here around 1905, was located in Hurley. The rooms, of course, were designed for single occupancy and were usually rented by miners. (Courtesy ICHM.)

In the first row of this logging camp photograph, the man seated fourth from the left and wearing a light-colored felt hat is Mr. Van Cleve of Oconto, Wisconsin. Van Cleve held the title of "mancatcher." His job entailed recruiting men to work on the range, in this case in a logging camp. Iron mines also sought labor from elsewhere. In his *Vein of Iron: The Pickands Mather Story*, Walter Havighurst tells that the Gogebic mancatcher was paid on commission to lure job seekers from downtown Chicago, buy them clothes and food, and take them by train to the Gogebic, where they were hired by various mining companies. (Courtesy ICHM.)

Located between Wakefield and Bessemer, the hamlet of Ramsay was originally known as Irondale. Similar to the hamlet of Gile farther west in Wisconsin, Ramsay started out as a lumber town with a sawmill adjacent to the Black River. (Courtesy ICHM.)

Once trees were cut, employment opportunities shifted to nearby mines. This is a view of Ramsay Location once mining opened. For a while, the Eureka-Asteroid Mining Company owned the town. Uniformly white houses dot the hillside. (Courtesy IAHS.)

This boardinghouse in Bonnie Location, east of Ironwood, has closed. Boardinghouses were an integral part of the Gogebic housing system during the range's formative years. Although many families took boarders at their homes, boardinghouses served many miners. These structures were designed for single occupancies. Without proper fire codes, the buildings occasionally erupted in flames, killing large groups of miners. Boardinghouses were not luxurious, and working in them was even worse: women woke up well before dawn each day to make breakfast and lunch. They then spent the rest of the day cleaning, scrubbing the ore dust out of clothes, and preparing dinner. (Courtesy IAHS, Ray Maurin Collection.)

Jessieville was initially settled by employees of the adjacent Newport Mine. Gogebic mining locations commonly featured a company store, family-owned grocery stores, a school, and a church. (Courtesy IAHS.)

42

Seen here, Reno Location was also known as North Aurora Location. Note the similar architectural styles, particularly the centralized chimney. In later years, this site had a drive-in theater, a baseball field, and an elementary school. (Courtesy IAHS.)

This early-20th-century map shows the street grid and property boundaries in downtown Ironwood. Many Gogebic Range towns have peculiar street layouts relative to most other Midwestern towns. The shape of each mining settlement is influenced by the locations of mine sites, subsidence areas, railroad lines, and incorporation of mining locations. (Courtesy IAHS.)

Looking northeast, this aerial view depicts Ironwood and Hurley in the mid-1900s, and given the angle of the shadows, during the late afternoon. On the right side are the shadows cast by the tailings piles. The Montreal River and downtown Hurley are in the lower portion. Hurley's initial street grid was laid out by the Northern Chief Iron Company of Wausau. The oldest part of Ironwood, shown at center, was platted by the Milwaukee, Lake Shore, and Western Railroad to have streets aligned parallel and perpendicular to its tracks. Mining towns generally lacked public space, because the corporations developing each town wanted to sell as much land as possible. Over time, local governments have stepped in and developed parks. (Courtesy IAHS.)

Three

A Built Landscape

Simply put, frontier life was hard. The potential of riches, not quality of life, led investors to mining districts. The built environments of many mining towns therefore often lacked a sense of permanency in terms of craftsmanship, materials, and architectural styles.

Since the range was settled in a hurry, iron dreams were more important than fancy housing. The *Oshkosh Times* described Bessemer's built environment in October 1885: "Towns are springing up all over the range, and settlers are coming in with a rapidity seldom seen even in a new iron region. Less than a year ago, the town site of Bessemer was a wilderness. . . . Today Bessemer, a bustling, busy, miniature city with hotels, stores, and saloons is forging ahead to take a front rank among the iron towns of northern Michigan and Wisconsin." The promotion of place generally focused on amenities and quality of life, taking an optimistic view of developments. Quickly developing towns in Gogebic country were also susceptible to raging fire. Most range towns were partially engulfed in flames at least once during the late 1800s. Many wooden buildings and sidewalks were reduced to ashes. After the fires, buildings were reconstructed with nicer, more permanent materials. The Gogebic County Courthouse in Bessemer is a prominent example, having been built of brownstone from the Bayfield Peninsula.

The mining ranges' built environment and architectural quality were often dependent upon companies' investments in their locations. Other mining ranges in the vicinity of Lake Superior, namely Minnesota's Mesabi and Michigan's Marquette and Copper Ranges, enjoyed a degree of long-term stability and prosperity, in which companies made civic investments into grand buildings and infrastructure. The Gogebic's boom-and-bust economy, with a high rate of absentee ownership of mines, led to less corporate involvement than what had occurred on the Mesabi, Marquette, and Copper Ranges. Even so, Ironwood fueled the opulent Ironwood Theatre and the Memorial Building during the prosperous 1920s.

Mining companies influenced architectural pattern. Within most Gogebic mining locations, similar ages and styles of homes were built in a simple grid pattern. In most cases, the firms themselves built houses and designed the initial street system.

Many Gogebic residents let cattle graze in their front yards, including upscale families such as the one depicted here. Today, some people might consider their pile of household goods junk, but during the Gogebic's early years, most families had little disposable income and material objects were a point of pride. Having one's photograph taken during the 19th century was a special occasion, so people wore their nicest clothes and proudly displayed their possessions. (Courtesy IAHS.)

Firefighters pose outside of the Ironwood City Hall in 1890. This building was torn down in 1990. (Courtesy IAHS.)

In the rush for red gold, housing was an afterthought. Like many other exploratory ventures, workers at the Norrie camp chopped down mature trees to build lodging. This photograph is from early 1886. (Courtesy IAHS.)

This view, taken at the end of the 19th century, shows a simple, flat-roofed cabin with a drying rack in front. The cabin stood along Black River Road north of Bessemer, back when Black River Harbor was a small fishing village. (Courtesy IAHS.)

In the mid-1890s, an isolated logging cabin is set amidst cleared lands with just a few spruce and birch remaining. (Courtesy IAHS, Wilbur Bridgman Collection.)

Shown here during remodeling, the Annala Barn is the only Finnish round barn near the Gogebic Range. Located south of Hurley, the barn was constructed by Matt Annala and his sons using rocks from their farm. (Courtesy IAHS, Ray Maurin Collection.)

This is a close-up of a window at the Bessemer City Hall, designed during the Depression. The building is generally a Tudor style, though the self-taught architect added some quirks. (Courtesy IAHS, Ray Maurin Collection.)

Ramsay's keystone bridge was built over the Black River in 1891. The span was constructed without mortar, using limestone shipped from Kaukauna, Wisconsin. The railroad's decision to build such a fine bridge is partly a reaction to previous bridges washing out here. The track is about 57 feet above the Black River's water level. (Courtesy IAHS.)

Many train depots have distinctive architecture, as exemplified by the steep roof pitch of the Ironwood depot. This structure was built from Lake Superior brownstone in 1892. Passenger service was phased out in the early 1970s. Currently, the depot has been renovated and is being used as the Ironwood Area Historical Society museum. (Courtesy IAHS.)

In 1917, the village of Hamilton was incorporated in Wisconsin. In 1924, it became the city of Montreal. Oglebay-Norton Company of Cleveland, Ohio, owned the entire town. In 1921, the company hired Alfred Taylor, a Cleveland-based landscape architect, to plan Montreal's land use. Looking west-southwest, this view was taken while the Montreal Mine was still in operation. State Highway 77 cuts through the center. Tailings piles can be seen along the left edge. Below the piles and to the left of Highway 77 is a long, narrow black rectangle. This is the shaded side of the machine shop's roof. The town's houses were built upon unusually large lots. In the upper right corner, conifers were planted. Oglebay-Norton owned a nursery in Montreal to promote landscaping in employee yards. (Courtesy IAHS.)

In the interest of beautifying the town, Albert Taylor's 1921 report suggested that Oglebay-Norton Company purchase one color of paint and sell it to employees at or below cost. Houses were painted white, and over 80 years later, Montreal is still dominated by white houses, though private ownership has resulted in a variety of colors and styles. Taylor also suggested selling vines for 25¢ apiece, to be planted next to unattractive buildings. (Courtesy IAHS, Ray Maurin Collection.)

The Oliver Mining Company had an office at 529 East Vaughn Street in Ironwood. H. W. Oliver of Pittsburgh appears on the front porch. Photographer Wilbur Bridgman might have wanted to showcase technological changes in the rapidly developing Gogebic landscape. Telephone poles flank the scene, and newspaper accounts indicate that telephone service came to the Gogebic Range in November 1886, only a few years before this photograph was taken. Mines, tailings piles, and a smokestack are in the background. Many images from the frontier Gogebic emphasized technological advance. (Courtesy IAHS, Wilbur Bridgman Collection.)

In the aftermath of the 1937 blizzard, street-level windows are hidden. Pedestrians experience a different sense of place when the snow towers above them. (Courtesy IAHS.)

This view looks south on Ironwood's Suffolk Street. Past the far end of the street, tailings piles are present. Woolworth's is on the left. (Courtesy IAHS.)

In this 1899 photograph, civic leaders from Bessemer and Ironwood pose outside of the Curry Hotel. The hotel was built in 1890 at the southwest corner of Lowell and Aurora Streets in Ironwood. (Courtesy IAHS.)

This late-1940s scene also depicts the Curry Hotel. The sidewalks and porch are drastically different compared to the above photograph, although many of the windows have the same shape; they are long and narrow, with a slight arch atop them. (Courtesy IAHS.)

The dining room at the Curry Hotel is pictured near the beginning of the Depression. The hotel was torn down during the 1950s. (Courtesy IAHS.)

The Curry House, not to be confused with the Curry Hotel, was the home of Solomon Curry. At various points in his life, the Canadian-born Curry managed several mines and banks. (Courtesy IAHS.)

Scandinavian Hall, shown here at the start of the 20th century, was located on the 200 block of East Vaughn Street in Ironwood. To the right is the Anton Larson Superior Bakery. (Courtesy IAHS.)

Mining locations usually had their own churches. In Newport Location, the Newport Methodist Church was built in 1913 and survived until 1983. (Courtesy IAHS.)

Looking southwest from the intersection of Iron and Third Streets, this 1904 view reveals the prominent Iron County Courthouse looming large. The Romanesque courthouse was built in 1893 as the town hall for Vaughn; it has since been converted into an impressive museum. The Iron County Historical Museum carries on the Finnish tradition of using looms to weave rugs from rags. It also features themed rooms, including the preserved courtroom. (Courtesy ICHM.)

Compare this late-20th-century photograph to the above view. On the first floor, the 1904 image shows a ramped entryway for the fire department. The ramp was later taken out, with bricks filling the bottom portion of the entryway and the arched window. There used to be a door on the lower left corner of the building. The clock tower now has black hands and numbers on a white background, whereas previously the colors were the reverse. (Courtesy ICHM.)

Today, the former Iron County Courthouse is Hurley's most recognizable building. But in earlier times, the Burton House, founded by 1880s booster John Burton, was the most famous structure in the region. Calling it "the hotel with a hundred windows," newspaper advertisements attested to the elegant food served there. After the mining boom ended, Burton sold his hotel to pay his creditors, repurchased it in 1896, and then traded it for a collection of approximately three million postage stamps, according to *Vein of Iron* by Walter Havighurst.

Taken around World War II, this view looks northwest toward the rear end of the Second Empire–styled Burton House. Dormers are set into the building's mansard roof. From this aerial perspective, decorative iron is also visible atop the roof. The Burton House burned down a few years later, on February 2, 1947. (Courtesy IAHS.)

Four

COMMUNITY AND SOCIAL LIFE

The late 1800s was definitely an era of yellow journalism. Today, citizens oftentimes complain about media bias, but this pales in comparison to the outlandish statements made in frontier newspapers. Looking back, it is amusing to read some of the newspaper articles, for they helped to develop reputations about places. Hurley's notoriety developed in large part through the print media. Newspaper articles shaped how communities were portrayed.

This chapter also delves into a set of lithographs from 1886 that are still highly popular on the range today. These lithographs are known as bird's-eye views for their aerial perspective. Local boosters funded the production of these views, making them a popular form of advertising. A prominent citizen's home or business could be listed at the bottom of the print in exchange for purchasing an agreed-upon number of copies. Commonly, an artist and his agent would travel to a town, utilize print media to get as much free advertising as possible, and sell as many copies as possible to residents, particularly civic leaders and businessmen. Lithographs could be cheaply reproduced, so ordinary citizens could afford reprints. In the case of the 1886 views of Hurley, Ironwood, and Bessemer, lithographs were produced by Henry Wellge of Norris, Wellge, and Company, a Milwaukee-based firm that traveled throughout the Midwest.

Henry Wellge walked the streets, paying great attention to the built environment, taking notes on each building. Of course, the artist saw each mining town at eye level, not the oblique aerial view portrayed on the lithograph. Wellge's bottom line was to make money, so he would want to sell as many lithographs as possible. To maximize his sales, Wellge would have to portray each landscape in a highly pleasing manner that best reflected the ideals of a town's residents. Due to the enduring popularity of bird's-eye view lithographs, this chapter spends a great deal of time analyzing how Gogebic communities were portrayed in 1886.

Lastly, this chapter explores Gogebic Range community organizations. Groups such as temperance societies, churches, and community centers sought to change Gogebic society for the better. Rather than trying to cover every single religious or civic institution, this chapter describes some common social organizations from the Gogebic's early days.

COPYRIGHTED & PUBLISHED BY NORRIS, WELLGE & CO. N° 205 SECOND ST. MILWAUKEE WIS.

1 Bingham & Perrin, General Merchandise,—Lumberyard—(Warehouse.
2 Lieberthal Bros. & Co., Dry Goods, Clothing, Boots and Shoes, Ocean Tickets and Drafts to all parts of the World
3 Aurora House, M. G. McGeehan.
4 Ironwood Store Co., L. N. Vrooman, Manager.
5 Walker House, P. S. Walker, Prop.
6 J. G. Kuehn & Co., City Meat Market.
7 Schilling's Block, J. F. Schilling, Prop.
8 Webb's House, W. W. Webb, Prop.
9 E. B. Williams, Hardware, Stoves and Tinware.
10 John W. McKay, Restaurant and Saloon.
12 J. E. Bean, Jewelery, Stationery and Musical Goods.
13 Mrs. O. H. Carus, Millinery and Fancy Goods.
 O. H. Carus, Real Estate Office.

A School House.
B Presbyterian Church.
C Catholic "

Firms such as Norris, Wellge, and Company produced lithographs of many locations throughout the country, and a common theme emerges: each town is depicted as progressive. Besides portraying progress and cultural sophistication, Wellge's lithographs were designed to place a positive spin on the economy. Near the horizon, billowing clouds of black smoke were intended to be a sign of industrial progress, unlike today, when black smoke equals air pollution. Whereas

OD, MICH.

N COUNTY.

86

P Post Office, Geo. F. Kelly, Postmaster.
D Passenger Depot, M. L. S. W. R'y.
E Ironwood Mining Review, { Will. Harrington, Editor. Iver Anderson, Manager.

14 Fred. M. Prescott, Mining and Mill Machinery & Supplies.
15 Geo. A. Smith, Blacksmith and Wagon Shops.
16 Larson, Johnson & Co., Groceries and General Merchan'e.
17 Ironwood House, Larson, Johnson & Co., Prop's.
18 W. L. Pierce, Residence.
19 Wm. Nelson, Barber Shop.
20 P. C. J. Miller, Ironwood Tivoli.
21 John Peterson, Saloon and Pool Room.
22 Milwaukee House and Saloon, John Erickson, Prop.
23 Melin & Kent, Saloon, Lunch and Pool Rooms.
24 M. C. McHale, Sample Room.
25 J. T. Atkison, "The Club" Saloon and Music Hall.
26 Joseph Dornan, Saloon and Music Hall,
27 Peter Montague, Boarding House and Saloon.
28 Marshall Bros., Groceries and Confectionery.

bird's-eye-view lithographs generally have straight, rectangular borders, in the Ironwood lithograph, the border is interrupted to show as many mines as possible. Although the artist could have "zoomed in" and increased the size of each settlement or added extra roads, trees around the edges imply natural resources and room for growth.

1 Howell & Grosse, Law Office, Real Estate, Explor. & Ins.
2 Gogebic Meat and Provision Co. EhrmanntrautBros., Prop
3 Osborn & Rutiman, Hardware and Mining Supplies.
4 Harrington Block, Patrick Harrington, Prop.
5 J. L. Strong, Drugs, Paints, Oils and Wall Paper.
6 J. T. Scaulin, Law Office, Real Estate and Exploring.
7 C. W. Week, Peoples Meat and Vegetable Market.

Compared to Sanborn Fire Insurance maps for accuracy, Gogebic lithographs usually have correct details for houses, depicting their quantity, architectural styles, and the accurate positioning of doors, windows, and chimneys. There are subtle differences, however, between objective accuracy and what was portrayed in other parts of the lithograph. The nature of the misrepresentations that occurred reveals how residents idealized Gogebic mining towns. Similar to other frontier locales, Gogebic towns projected their sense of community, progressiveness, sophistication, and

13 Alfred Peterson, & Co., Saloon and Pool Room.
14 Kallander & Johnson, " "
15 Haring & Chynoweth, General Merchandise.
16 John Holland, Blacksmith and Wagon Shop.
17 John Hoberg, Gen'l Store, Saloon, Real Estate & Build
18 Wilhelm Kulaszewicz, Saloon and Pool Room.
19 M. H. Martin, General Merchandise.
20 Bond & Clancy, " "

physical attractiveness. Civic boosters used geography to justify the prominence of their town over competing hamlets. Individual range communities promoted themselves as boomtowns. They vied with one another in advancing such claims. For a frontier community, the development of roads, the erection of buildings, and the development of mines were indicators that the Gogebic's towns were there for the long run. Bird's-eye-view lithographs, designed by traveling artists, reveal insights into the hopes of settlers during the Gogebic's boom years.

COPYRIGHTED & PUBLISHED BY NORRIS, WELLGE & CO. N⁰ 205 SECOND ST. MILWAUKEE WIS.

1 Moore & McFerran, General Merchandise.
2 Moore & Agnew, Hardware.
3 Iron Exchange Bank, W. S. Reynolds, Cashier.
4 Brill & Langdon, Dry Goods, Clothings, Boots & Shoes, Miners Supplies
5 A. K. Lord & Co., Jewelers and Music Dealers.
6 C. H. Hammersley & Co., Drugs, Paints and Oils.
7 Hohmann & Voigt, Stoves, Tin and Hardware.
8 C. Jacobson, Jewelers and Optical Goods.
9 F. D. Day & Co., General Merchandise.
10 C. B. McLean, Groceries and Provisions.
11 Blackburn's Red Front. Residence.
12 Matthew J. Hart & Co., Druggists and Apothecaries.
13 C. Reible, Bakery, Confectionery and Restaurant.
14 Gogebic Meat and Provision Co.
 Wetzler Bros, & Ehrmanntraut Bros, Prop's.

A School House.
B Presbyterian Church.
C Catholic "
D M. L. S. & W. R'y Depot.
F Post Office

HURL

ASHL

Here, straight street grids are depicted in a light color to show human power over nature; human progress could indeed impose a system over hilly terrain. In some cases, Wellge extended roads farther than they actually were at the time. For example, this lithograph of Hurley depicts Iron and First Streets intersecting. But on the 1888 Sanborn Fire Insurance map of Hurley, these streets are each shorter in length and do not meet. Not only was the quantity of roads misrepresented,

64

NEWSPAPERS.
G Gogebic Iron Tribune, F. B. Hand, Editor.
H The Miner, Gaudly & Goodell, Editor.

I Burton House, John E. Burton, Prop.
II Burton Block, " " "

15 B. W. Bicksler, Furniture, Undertaking, Dry Goods and No
16 W. A. Richard & Co., General Hardware.
17 Davis & Hansen, Clothing and Gents' Furnishings.
18 Paiske Bros., Fancy Groceries.
19 Heinemann Bros., General Merchandise.
20 Cohen & Finn, Clothing, Gents' Furnishings, Boots and Sho
21 Seymour & Durkee, Foundry and Machine Shop.
22 A. A. Breitung, Wagon, Blacksmith and Shoeing Shop.
23 Adams House. John Adams, Prop.
24 Caledonia Hotel, D. P. McNeil, Prop.
25 Grand Central Theatre, Geo. C. Young, Prop.
26 Ellis & McCammis House.
27 F. D. Abell & Co., Contractors and Builders, Dealers in (Lumber, Office in Rear of Bank.
28 A. J. Robertson, Bakery and Confectionery.

so too was the quality of roads. By depicting them in a uniformly light color, the lithograph made the roads stand out, implying refined smoothness. In actuality, the roads of Gogebic towns were muddy, filled with potholes, ruts, and chunks of black basalt rock. Photographs from 1886 show streets marked by potholes and stumps. Gogebic Range lithographs never included the piles of stumps and logs present alongside the town's routes.

65

To depict economic vitality, numerous trains are shown on the tracks, each car filled as high as possible with iron ore. The Bessemer lithograph has no fewer than 12 fully loaded trains. This many separate ore trains present at one time is a lot for such a small town, especially considering that for every loaded train taking ore to port, there should be an empty one making a return trip. In his effort to cram so many trains into one scene, Wellge even drew two on the same track, one block apart, ready for a head-on collision!

Inset images, which were often inserted in the lower corners, aim to show the previous year's progress. The three Gogebic Range lithographs each had identical images, even though the captions were differently worded. The right photograph gives an industrious view of Bessemer's Colby Mine, whereas the one to the left shows pioneers chopping away at old-growth forest. Combined, these two images are designed to offer a narrative of Gogebic Range progress. Captions from each of the three lithographs tell a story of the range being transformed from "wilderness" into sophistication.

66

The main street in Iron Belt celebrates with a parade in 1911. As towns developed, their roads improved. But during the Gogebic's first few years, local newspapers were often making appeals to civic leaders to improve road quality. At the end of May 1886, the *Gogebic Iron Tribune* thought that road construction and maintenance was overlooked, mentioning the lack of a uniform grade on even the busiest streets. On June 2, 1887, the *Montreal River Miner* hoped for roads constructed of a "thick coat of refuse, rock and ore from mines, and not be covered with mud at every rainfall." The roads improved greatly over a generation's time. (Courtesy ICHM.)

Aurora Street in downtown Ironwood is pictured in mid-1886, about the same time as the lithographs of Gogebic towns. During the frontier days, most places around town had rubbish and lumber lying around. In July 1886, the *Gogebic Iron Tribune* felt compelled to comment, "Every citizen should clear up all garbage and rubbish that may have accumulated around his premises. The public health is threatened. . . . Let the street commissioner see to it that every cesspool is cleansed and disinfected with chloride of lime." Clearly, these towns are not as tidy as the lithograph showed. (Courtesy IAHS.)

Given the region's abundant snowfall, clearing roads and sidewalks was quite a challenge, especially prior to modern snowplows. Snow would be dumped between the road and sidewalk, blocking storefront views from the street. These piles occasionally went as high as the first story. (Courtesy IAHS.)

Shoveling snow, in this case, was a community event. Note the teenager atop a telephone pole. Based on the line where the snow meets that telephone pole, the snow pile is taller than each of the shovelers. (Courtesy ICHM.)

Revelers congregate outside the Nelson Tavern in Iron Belt during Fourth of July festivities in 1907. As range hamlets grew, fraternal societies organized chapters, the membership of which was commonly based upon ethnicity. (Courtesy ICHM.)

Taken on July 4, 1918, this photograph shows the surviving five members of Pleasanton Post No. 429 for Civil War Veterans. The veterans pose outside Carnegie Library following their participation in Ironwood's Fourth of July parade. (Courtesy IAHS.)

Seen here is the dedication ceremony for Ironwood's Memorial Building. The building was constructed as a tribute to those who served in World War I. Inside, the Heritage Room display is being created, offering exhibits on the city's history. (Courtesy IAHS.)

Upper-class guests at Wilbur Bridgman's home strike a pose for the camera during the mid-1890s. Bridgman served as assistant superintendent of Ironwood schools and founded the *Iron County Republican* in Hurley. (Courtesy IAHS, Wilbur Bridgman Collection.)

Ulvin's Store in Gile sold clothes, household tools, and dry goods such as boxes of biscuits and tubs of lard. In newspapers from the Gogebic's frontier era, it is oftentimes hard to tell where editorials stop and advertisements start. Oftentimes publications such as the *Montreal River Miner* or the *Gogebic Iron Tribune* would promote general stores directly in their columns. (Courtesy ICHM.)

This photograph shows the employees of the Jackson and Wiita General Store in Iron Belt. The building burned down in 1913. (Courtesy ICHM.)

Here, four women and their male boss work at a laundry cleaning business. In a male-dominated frontier setting, the stories of women are often left out. This is probably because not only were there far more men than women, but also preserved historical documents from the early Gogebic tend to be from male-dominated occupations such as mining and store keeping. Nonetheless, women worked equally hard. They completed unpaid labor in thankless yet necessary tasks like cooking, cleaning, sewing, raising children, working on the farm, and in a few cases, driving gravel trucks to provide supplementary income. Sometimes extra space in a house would be rented out to a miner or two, with a woman taking care of the cleaning and cooking for that miner in addition to her family. (Courtesy IAHS.)

The Northern Bakery, its bakers and delivery truck shown here, was located on East Ayer Street in Ironwood. Each wooden crate commonly held 35 or 40 pounds of bread at a time. (Courtesy IAHS.)

Mining companies usually employed their own doctors. This 1930s photograph depicts the Montreal Mine Clinic. Owner Oglebay-Norton Company provided inexpensive medical care for employees of the mine. (Courtesy ICHM.)

The Hamilton Club was a community center for employees of the Montreal Mine and their families. Company Christmas parties, craft classes, movies, and bowling are some of the activities that occurred in this building. At the time, the contrast between the paternalism of company-owned towns and the lack of social control in places like Hurley became even more striking. The Cleveland-based Oglebay-Norton Company owned the entire nearby village of Montreal. In an effort to maximize employee potential, the firm banned alcohol. Miners looking for drinks and entertainment were forced to head two miles east to Hurley. That town therefore maintained its abnormally large and populous hinterland of customers due to its geographical location; Hurley was close to the dry Montreal Location and just across the Montreal River from many customers in Ironwood. (Courtesy ICHM.)

Hurley's infamous Silver Street is shown in this 1887 view looking east from Fifth Avenue. The flatiron building is on the left side. Although most mining ranges had a couple of towns known for their wild atmosphere during the frontier years, Hurley's reputation would last through the present day partially due to the sustained number of bars along Silver Street. This photograph was taken before the mid-1887 fires in the Alcazar Theatre. Afterward, many of Hurley's buildings were rebuilt with more durable materials such as brick. (Courtesy ICHM.)

Generally, frontier areas had different sets of morality than areas with more established economic activity. Mining towns were no exception, owing to their disproportionately high ratio of males to females, which meant that few miners had families or felt any social constraint in their behavior. At least through 1887, the entire Gogebic Range was notorious. Bessemer, Wakefield, and Hurley had particularly unsavory reputations. Differences in state liquor laws grew, with Michigan enacting stricter legislation. But laws alone do not explain Hurley's situation; elsewhere in Wisconsin, other towns near the Michigan border like Florence, Land O'Lakes, Niagara, and Marinette did not rival Hurley's reputation. (Courtesy IAHS.)

Streetcar lines cut through the 400 block of Silver Street on a calm morning in 1896. Men were attracted to variety houses and saloons, which usually had vertically stratified areas of unsavory activity; typically, the buildings included bars on the first floor, gambling in the basement, and brothels in the rooms on the second floor. Readers on the east coast occasionally heard news of the wild times on this street. The front page of the December 31, 1886, *New York Times* asserted, "The State line is now fairly alive with stockades and slave pens from which there is no escape for the women who enter. . . . The passage of more stringent laws will root out dens that are situated on the State lines. The proprietors of the houses find it convenient to move from Michigan to Wisconsin, or vice versa, as necessity arises." Commonly, newspapers from elsewhere described social problems with colorful language, claiming that the region was filled with "dens of infamy." (Courtesy ICHM.)

Posing in their Sunday best, these men display a placid demeanor in opposition to the wildness of many range taverns. Note the round, light-colored spittoons on the floor and around them the deep stains of chewing tobacco. According to the 1888 Gogebic Range Business Directory, Ironwood had 55 saloons, whereas Hurley had 52, Bessemer 48, and Wakefield 24. In terms of bars per capita, Wakefield and Pence led the way, owing to their smaller populations. But by 1893, Hurley had far more saloons per capita than other range towns. (Courtesy IAHS.)

By 1890, Hurley's sordid reputation would be crystallized by the reporting of a single event. Early in the morning of April 11, 1890, the body of prostitute Lottie Morgan was found lying in a pool of blood. Lottie had been shot, her head smashed open by an ax. Newspapers in other cities denounced Hurley for both the high attendance at a prostitute's funeral and the town's inability to prosecute her killer. Whether justified or not, the Lottie Morgan incident did much to fix permanently the town's reputation. The unsolved crime became the subject of *Come and Get It* by Pulitzer Prize–winning author Edna Ferber. (Courtesy ICHM.)

The *Svensk-Finska Nykterhetsforbundet*, or Swedish-Finnish Temperance Society of America, advocated greater societal control over the geographical areas served by its chapters. The Ironwood chapter is pictured here in the early 1900s. During their first few decades, Gogebic Range social organizations were usually divided along ethnic lines. (Courtesy IAHS.)

Bessemer's Shelter Temperance Society members pose for a 1920 photograph. As is often the case with historic photographs, the people are wearing their finest clothes. Considering that they are trying to make their setting seem as pleasant as possible for the camera, note the landscaping in front of the wooden sidewalk. The temperance society was probably not going to dress up fancy just to sit behind unusually ragged weeds, so we can infer that weeds like this were fairly typical during the era. (Courtesy IAHS.)

The Holy Trinity Church in Ironwood celebrated its 50th anniversary in 1941. Religion varied by ethnicity, as it did elsewhere. Immigrants from northern Europe were likely to belong to a Protestant denomination, whereas southern and eastern Europeans tended to be Catholic. Throughout its history, the range has been a mixture of the two. In addition, a Jewish synagogue was established in Hurley. (Courtesy IAHS.)

A large crowd attended the cornerstone ceremony for St. Paul's Episcopal Church on July 7, 1896. The congregation changed its name to the Church of the Transfiguration after construction was finished. The stone and lumber used in the building process were obtained from elsewhere on the Gogebic. (Courtesy IAHS.)

Five

MINING

The Gogebic's deep mine shafts were dangerous places to make a living. Some miners were killed by explosions. Others were buried alive by tumbling rock. A few men plunged to their deaths down the shafts. Many miners developed silicosis and other respiratory diseases due to overexposure to rock dust. Gradually, safety standards improved.

The Lake Superior mining region has had a long tradition of union activism. Finns, in particular, had a strong tradition of working-class politics back in Finland. On the Lake Superior ranges, the "Red Finns" applied their organizing skills to become leaders of local socialist unions. To maximize productivity, companies would thwart strikes any way possible. Mining firms controlled their geographical territory in large part for this purpose. Montreal, Wisconsin, was perhaps the range's most paternalistic place. Since the Oglebay-Norton Company owned the entire town, including workers' housing, labor activists could become both jobless and homeless.

In 1892, the Gogebic led Lake Superior iron ranges in ore production, only to be followed by a stock crash in 1893. Minnesota's Mesabi Range, in its infancy, led the Lake Superior mining ranges for years to come. During the year 1920, the Gogebic had its greatest shipments of iron ore as well as its highest population. The 1920s and both world wars brought added demand for Gogebic ore, whereas the 1930s Depression hurt iron demand.

Some range mines continued to do well until the 1950s, when production costs simply became too great for them to compete. Shallower deposits were well suited for open-pit mining, but few open-pit mines existed on the Gogebic, which hosted some of the world's deepest iron mines during its heyday. Technological advance made it easier to develop low-grade ore from other iron ranges, meaning that Gogebic high-quality ore was no longer worth the added cost of extraction. Gradually, mines closed and the region declined economically, being insufficiently diversified to sustain growth. In 1966, the Peterson Mine closed, shipping its last stockpile during the following year. This marked the end of an era. Approximately 318 million tons of iron ore left the Gogebic's worn-down hills between 1884 and 1967. However, more than any other theme in this book, the Gogebic Range still sustains its reputation as a rough-and-tumble mining region.

When thinking of idealized rural scenery, we often imagine bucolic farms with colorful crops, majestic mountain peaks, lighthouses atop wave-splashed coasts, or forests atop rolling hills. Mining landscapes, however, seldom grace the pages of yearly calendars. In his 1991 book, geographer Richard Francaviglia asserts that mining landscapes have been largely ignored, and tells much about the relationships between power, landscape, and boosterism. "Mining landscapes . . . should be viewed as icons of power. Forged as a result of aggressive investment and speculation in reaction to more or less uncontrollable economic and political situations, they are battlegrounds that show victory and defeat." The Gogebic's cultural scenery reflects the money invested into it. Mining landscapes are not subtle, as shown in this 1940s view of the Penokee Mine. (Courtesy IAHS.)

Snow conceals most of the bare earth in this mid-1890s scene at the Aurora Mine. Overall, the Gogebic's iron deposits are deeper than most deposits elsewhere in the Lake Superior mining region. However, since iron was found near the surface, many mines started out as open pits. After a short depth, standard underground mines became more feasible. (Courtesy IAHS, Wilbur Bridgman Collection.)

Prior to entering mines, employees changed out of their street clothes. Miners would also wash up upon ending their shifts. Here, a seemingly endless row of sinks begins at the lower right corner and continues to the back of the washroom. (Courtesy IAHS.)

Miners experienced a starkly different sense of place once they entered the underground labyrinth of work. A photograph such as this cannot capture the high humidity and cold, clammy temperature deep inside the earth. Regardless of the time of year, mine temperatures fluctuated little. (Courtesy IAHS.)

Seen here is a shaft house at the Penokee Mine. Headframes and shaft houses are basically the same, except that the latter are partially enclosed with walls. These structures are used to support the pulley system for getting people and materials in and out of the mine. Infrequently, mine shafts were housed in a more elaborate building, such as the art-deco Cary Mine Building west of Hurley. (Courtesy IAHS.)

Before the Montreal Mine's No. 5 Shaft House was torn down in 1962, it was an imposing feature on the landscape. At the time of its closure, the Montreal was regarded as the deepest iron-ore mine in the world. (Courtesy ICHM.)

C SHAFT – EAST NORRIE MINE
DEPTHS AND ELEVATIONS

SCALE - 1" = 300'

- 1st Lev. Depth- 318' Elev.- 1303'
- 2nd Lev. Depth- 470' Elev.- 1165'
- 3rd Lev. Depth- 623' Elev.- 1028'
- 4th Lev. Depth- 776' Elev.- 889'
- 13th Lev. Depth- 927' Elev.- 754'
- 17th Lev. Depth- 1213' Elev.- 498'
- 19th Lev. Depth- 1405' Elev.- 321'
- Bottom Depth- 1460' Elev.- 271'

The Gogebic's ore deposits are in narrow, deep bands. The deposits are not entirely vertical, but rather tilt to the north at about a 65-degree angle. In some cases, mining companies drilled vertical shafts intersected by horizontal levels. Other mines, such as the East Norrie Mine's C Shaft, followed the footwall. In mining, a footwall is where useless rock is underneath the rich ore. By looking at this map of the East Norrie shaft, one can infer that the footwall is where the diagonal line comes down from the upper left corner of the map. As the mines plunge into the earth, they are also headed north. Horizontal levels extended outward to reach the ore deposits. Due to resizing, the scale on this map is no longer correct; 1,371 vertical feet are represented on this map between the surface and the bottom level. (Courtesy IAHS.)

A miner prepares to load dynamite into pre-drilled holes to maximize efficiency. If holes were not pre-drilled, and the dynamite was instead set next to the rock, less energy would be directed into the solid rock. (Courtesy IAHS.)

This northwest view shows the Aurora Mine's E Shaft, which reached a depth of 1,500 feet below the surface. Almost all mine operations had more than one shaft, and companies generally used sequential letters or numbers to differentiate between them. (Courtesy IAHS.)

Just northeast of Sunday Lake, Wakefield's Pike Mine No. 2 Shaft was developed in 1902. The Pike Mine also had a shaft farther west along Sunday Lake. Iron was discovered along the lake in 1881. Wakefield had also gained attention by being the nearest settlement to the 1880s gold and silver explorations. (Courtesy ICHM.)

These Aurora miners wear candles on their helmets for lighting purposes. Many also hold shiny pails serving as lunch buckets. This photograph was taken in front of one of the Aurora's headframes. (Courtesy IAHS.)

The Colby Mine's No. 2 Shaft workers pose with their lunch pails around 1907. At this mine, iron ore was discovered without even having to dig. Uprooted trees usually have some of the soil's top layers stuck in their roots. In 1872, at what was to become the Colby site, Richard Langford noticed iron ore tangled amidst the soil and roots of an overturned tree. Coupled with financial backing, this led to the Gogebic's development. Previously, surveyors and geologists such as John Burt in 1847, J. G. Norwood in 1847, Charles Whittlesey in 1849 and 1860, Raphael Pumpelly in 1871, and Thomas Brooks in 1872 had each indicated that ore was present on what is now known as the Gogebic Range. (Courtesy IAHS.)

Miners pose at the Norrie Mine's No. 2 Shaft in the 1890s. Capt. James Wood and A. Lanfear Norrie of New York found ore at the Norrie site in 1882, and the shaft started operating in 1886. Between 1882 and 1962, the Norrie was one of the Gogebic's most productive mines. (Courtesy IAHS.)

The old Germania Mine is pictured about 1906. With less influence from mining companies than Ironwood, Hurley had less social control than its counterpart across the river. Since mining companies sought to control their geographical spaces as part of an effort to increase employee productivity, miners often traveled to less-regulated places for trouble. (Courtesy ICHM.)

This 1920 view depicts the Vaughn Mine. Jessieville Location and the Newport Mine are at the ridge in the distance. (Courtesy IAHS.)

Just east of the state border, the Ashland Mine operated between 1885 and 1926. This view, looking west-southwest, shows the mine at the beginning of the 20th century. Behind the children, but before the tailings piles, lies a field of cedar stumps. Some records show this area as swamp prior to development; perhaps unstable soils contributed to the telephone poles all leaning awkwardly. (Courtesy IAHS.)

A rock crusher runs near Ironwood's Mt. Zion in 1911. Behind it, the valley reflects the rectangular land division patterns of the town-and-range system. (Courtesy IAHS.)

This steam-powered shovel was operated by the Lake Superior Consolidated Iron Mining Company. During the financial panic of 1893, John Rockefeller bought up mines throughout the Lake Superior mining region and managed them until 1900, at which point he sold the firm to J. P. Morgan, who formed U.S. Steel. Consolidation actions such as these made geography less visible: an investor need not select a geographical location but rather focus on the quality of a company. However, during the unstructured exploration of the 1880s Gogebic Range, this was not really the case. The localized nature of mining speculation on the Gogebic demanded more overt geographical information. (Courtesy IAHS.)

To expedite the removal of ore from mines, conveyor belt systems were established. Note the lightbulb on the ceiling. (Courtesy IAHS.)

From conveyors, ore went into haulage cars, which were used to move ore and waste rock. A warning bell is on the end car. Mine shaft width restricted the width of haulage cars. (Courtesy IAHS.)

To provide a bit of support as well as protect the workers from falling rock, mine shafts were "timbered," or flanked by lined-up logs. During the late 1800s, newspaper stories frequently mentioned hemlock as a popular tree to timber the shafts. Tamarac became increasingly common. In later years, such as here on the Newport Mine's 30th level, steel beams were used to secure the timbering in place. (Courtesy IAHS.)

Midway between the cities of Bessemer and Ironwood, the Geneva Mine reached a depth of 3,358 feet below the ground, which is almost 1,700 feet below sea level. These rail tracks are on the Geneva's 33rd level. Pumps constantly removed water; as the mines closed, waters rose. (Courtesy IAHS.)

Needless to say, mine labor was dangerous. Here, smoke rising from the ground is evidence of an underground fire at the Windsor Mine. Historian Bruce Cox has researched well over 1,000 mine fatalities during the Gogebic's mining era. (Courtesy ICHM.)

As miners prepared to descend into the earth, they were keenly aware that each day could be their last. In the range's earliest days, with few safety precautions, workers often lived with a degree of fatalism, basically thinking that "whatever happens, happens." Gogebic County employed a mine inspector who kept statistics on the cause of accidents. The 1892–1893 Inspector's Report reveals that 1 out every 119 miners died on the job. Shafts caving in, ore tumbling down, and miners falling caused the most deaths that year. (Courtesy IAHS.)

Most of the miners rescued in the September 1926 Pabst Mine Disaster are pictured here. Three workers were killed when a cable snapped because of falling rock, plunging them 1,900 feet to the bottom of the Pabst. Falling rock then wedged in the shaft, trapping 40 miners on the 8th level, 2 more on the 13th, and 1 on the 18th. Newspaper accounts varied, but all indicated that at least 5,000 people anxiously waited outside the Pabst Mine. After 129 hours of being trapped, miners once again emerged above ground. The rescue made front-page headlines throughout the country. (Courtesy IAHS.)

As the Pabst Mine Disaster unfolded, the United States Bureau of Mines train car arrived, equipped to give first aid to rescued miners. Most miners then met their families before going to the hospital for further treatment. They were weak from dehydration and lack of food; one man was so desperate that while underground he ate three corncob pipes, according to the December 1926 issue of *Popular Science Monthly*. (Courtesy IAHS.)

$6.00 Per day for 6 hours work.

Abolition of the contract system.

Abolition of blacklisting of our fellow workers.

$4.00 for 8 hours work for surface men.

These are our Main demands. Of course there are local grievances in nearly every locality that have to be taken up separately with the local mining companies.

NOW, THEN, FELLOW WORKERS,

We do appeal to you to start with the miners of the Gogebic Range

Declare the Strike! Walk Out! Stay Out!

Fight with us until our demands are met.

STRIKE COMMITTEE.

While iron ore was in demand during World War I, unions had more leverage with management. Miners in Bessemer voted to go on strike in July 1917. The Industrial Workers of the World used this flyer to encourage striking on other Lake Superior mining ranges in tandem with Gogebic strikes. (Courtesy Arnold Alanen.)

The Montreal Mine's No. 4 Engine House was constructed of fieldstone. Compared to many companies, Oglebay-Norton Company took exceptional care of Montreal. The firm also repaired its workers' houses and mowed their lawns. (Courtesy ICHM.)

Partially covered with ivy, the Montreal Mine's machine shop appears in the foreground, while the Hamilton Club is tucked behind the parked car. The No. 5 Shaft looms beyond the Hamilton Club. (Courtesy ICHM.)

As they went deeper into the earth, some mine shafts followed the iron deposits at about a 65-degree angle, whereas others were sunk vertically, as is the case with the Montreal Mine's No. 5. This portion of the shaft map shows the upper 1,600 feet of the mine. Two years' time, between September 1921 and 1923, was needed for the shaft to reach below sea level. At the time of its closure, the mine was more than 3,000 feet deep. (Courtesy ICHM.)

Almost all of the Gogebic mines consisted of underground shafts. In the late 1800s, when mines were first developed, many were initially open pit, since ore was close to the surface. The narrow, deep bands of ore are better suited for underground mining. Two exceptions are the Plymouth and Wakefield open-pit mines, which shared opposite halves of this canyon. (Courtesy IAHS.)

Canyons rise from the base of the Plymouth open-pit mine in the 1940s. Located near Wakefield, the Plymouth open-pit mine closed in 1955. Foreign iron was more likely to come from open-pit operations; the Gogebic's deep mines could not compete. Since many skyscrapers were being built on the east and west coasts, transportation from foreign countries was becoming easier. (Courtesy IAHS.)

Tailings piles dot the snow-filled scene. They are important to preserve since few other readily visible elements of the mining landscape remain. (Courtesy ICHM.)

Snow coves the tailings piles in this photograph. Since tailings piles are heaps of leftover rock removed from the mines, they have extremely little soil. Nonetheless, trees and grasses occasionally manage to grow on the range's abandoned tailings piles. Though they may be seen nostalgically by those interested in the mining era, to others tailings piles are a symbol of humanity's recklessness with nature. (Courtesy IAHS, Ray Maurin Collection.)

Enough material was removed from some Gogebic mines that the land became unstable and slumped. In this oblique aerial view, water covers the site of the former Ashland Mine in Ironwood. Some locals refer to these as the "caves," whereas maps label these as "subsidence areas" or "sunken areas." Regardless, these zones shape Gogebic Range geography by influencing land values, land-use patterns, and the arrangement of roads in several municipalities. (Courtesy IAHS, Ray Maurin Collection.)

Six
Rural Transformation

It has been shown how mining results in distinct cultural landscapes. This chapter focuses on other ways Gogebic Range residents and the land have shaped each other, particularly through lumbering and farming.

During the Gogebic's mining boom, land speculation was rampant. Most of this was due to the possibility of valuable minerals beneath the soil, but newspapers often paid attention to the resources of the soil itself. The December 18, 1886, issue of the *Chicago Inter-Ocean* romanticized the Gogebic's landscape: "The timber is a heavy hardwood growth . . . a magnificently timber country with its hills and valleys rolling away in uniform splendor." The forests described by this newspaper are far different from those we see today. Land surveyors' notes provide insight into the types of trees found on the Gogebic during the 1800s. These include pine, mixed hardwoods, and hemlock.

After the forests had been cleared, lumber companies were eager to dispose of their lands. All sorts of folks advocated farming the Gogebic Range and environs. These groups ranged from local newspaper editors all the way to the Wisconsin state government. Regardless of what promoters said and what settlers tried to do, the North Country's physical geography ruled. First, stumps had to be removed. Dynamite was often used to expedite this process. Glaciers had scraped ample boulders away from Canada and left them all over the Gogebic countryside, which made plowing a hassle. Poor, acidic soils held little water and nutrients, though northern Iron County has extra clay, which is able to hold more moisture. To top it off, the harsh climate brought short growing seasons, though it should be noted that Lake Superior's moderating influence actually lengthened the growing season north of the range.

Of course, farms are still to be found here and there in Gogebic and northern Iron County today, especially those growing hay and dairying. But in the big scheme of things, most farms had a tough time. Compared to life in the damp underground mines, however, farming was desirable.

Prospectors explored for copper intermittently between the 1840s and 1902, but nothing economically viable was found at Copper Falls State Park. Some prospecting occurred alongside the Bad River just north of Copper Falls; however, problems abounded when the surging river would flood the miners' exploratory pits. In 1902, dynamite solved the miners' crises. By blasting away at part of the riverbed, most of the river's flow was diverted to the left half of the falls. All of this roaring water undercut the left bank (not shown) throughout the 20th century, which caused a series of rock falls in the late 1980s. Erosion is a natural process, but miners accelerated change by diverting river flow. The miners themselves were out of luck, as no commercially viable copper was discovered. Their legacy lives on in what, at first glance, appears to be a scene untouched by humans. Due to their actions in 1902, though, Copper Falls today looks distinctly different than this Depression-era photograph.

This view depicts Upson Falls in Iron County. During the first few decades of Gogebic settlement, many Americans believed in an idea called environmental determinism, which meant that each place's landscape and climate influenced how successful people were. For example, an 1886 brochure from the Milwaukee, Lake Shore, and Western Railroad tried to cast the area in a healthful light, no doubt to promote revenue from tourism. It extolled the healing powers of the local climate. "Those suffering from pulmonary or miasmatic troubles are greatly benefited [sic] at Gogebic. . . . In cases of hay-fever, the climate exerts a magic-like influence and has never failed to completely cure the suffering patients." The brochure included photographs of nearby waterfalls and of the distant Porcupine Mountains. Very few people give credence to environmental determinism today, but during the early Gogebic, many believed that waterfalls were healthy places and therefore made humans healthy. Scenic beauty and health combined to make waterfalls one of the most popular Gogebic landscapes during the late 1800s and early 1900s. (Courtesy ICHM.)

These bluffs are located between Bessemer and Wakefield. Almost two billion years ago, the region was underwater. Volcanoes spewed up lava, including basalt, which forms the line of hills just north of Gogebic towns. Later, earthquakes tilted the land. One result of this tectonic activity was the formation of steep mountains, which over time weathered into hills. These bluffs, home to lava rock, were given attention by late-1800s travelers. Newspapers from elsewhere often described the Gogebic's physical setting, such as the following example from the May 11, 1886, issue of the *Burlington* (Wisconsin) *Free Press*: "In these magnificent hills and silent valleys there have been reposing through the ages the largest and most valuable deposits of steel producing ores in the known world." (Courtesy IAHS.)

This bucolic 1930s view looks north toward the rocky bluffs on the eastern end of the Gogebic Range. Boosterist literature featured both hillsides and valleys as excellent settlement sites; for example, the *Montreal River Miner* claimed that Hurley's position on a hillside would make it the most successful city on the Gogebic Range. The *Miner and Manufacturer*, a Milwaukee-based newspaper, stated that Bessemer's setting in a valley would make it the "metropolis of the Range."

Abandoned mining landscapes are home to different ecological species than less-disturbed forests. Over time, natural processes obscure these disturbed landscapes. In front of the tailings piles, pioneer species such as aspen, box elder, and dogwood reforest the land. Many people do not think of nature and culture together. But even in this supposed natural landscape, there is a great deal of culture: Gogebic Range settlers removed trees, which led to lots of sunlight reaching the ground, and these pioneer species thrived in full sunlight. Even though humans did not plant these trees, their dominance in this landscape is made possible by previous human transactions with the land. (Courtesy IAHS.)

These men are pictured at the Gile sand hill at the start of the 20th century. Although Gile was a lumbering town, it had similar demographics to nearby mining towns; the workforce was dominantly comprised of young men without families. During the Gogebic's earliest years, French Canadians, Irish, and Scotch comprised most of the workforce. As the lumber industry matured, however, the ethnic makeup shifted to Scandinavians and Eastern Europeans. (Courtesy ICHM.)

At the dawn of the 20th century, Wisconsin and Michigan were the top two states for lumber production. This view shows the Vogel Mill in Upson on April 18, 1904. The building had been enlarged several times. (Courtesy ICHM.)

Icicles dangle along the edge of a logging camp roof in the 1890s. Deep snow insulated the drafty log cabins on the Gogebic from even colder temperatures outside. Winter was the busy season for lumbering since the spring melt's roaring waters were the most efficient time of year to float pine downstream. Frozen soils also gave greater support when hauling heavy loads. (Courtesy IAHS.)

Horses stand by as men adjust the logs. Old-growth logs have their own secrets. Tree rings give clues to the past, since climate affects the width of the tree rings; of course, variables such as temperature, rainfall, and amount of sunlight each affects tree growth. Tree rings can also show a scar after fires occurred; by counting the number of tree rings between fire scars, one can find out how often forest fires occurred. Before the lumbering era, fires seldom occurred in Gogebic forests. (Courtesy IAHS.)

Men and mules gather at a logging camp east of Wakefield in 1927. The time is late in the Northwoods lumber camp era, though many places near steep terrain had been bypassed at first. For example, the rough terrain of Michigan's Porcupine Mountains State Park deterred much logging. Park supporters were hoping for status as a National Park System unit, but 1940s logging threats provoked the Michigan legislature to make Porcupine Mountains a state park in 1945. (Courtesy IAHS.)

The massive quantities of lumber chopped out of the forests required immense mills. Scenes like this dotted the range landscape during the lumbering era. Previously, forests of the Upper Great Lakes endured localized disturbances, but not clear-cutting. Lightning strikes, windfalls, and tree disasters were the main source of forrest disturbance near Lake Superior. (Courtesy IAHS.)

The Scott and Howe Lumber Mill is pictured on May 23, 1903. Upon closer inspection, over 80 people are gathered on the ground and on the log chute; many work at the mill, but families with small children are also present. This photograph's most interesting story is not the people themselves, but rather the size of the operations needed to refine forest products. (Courtesy IAHS.)

Located on the east bank of the Montreal River's west branch, the hamlet of Gile began as a lumbering community. This scene displays the Norman Lumber Mill, which was built in 1910 and burned down five years later. Since many of the Gogebic Range's early mills were basically dry wooden buildings filled with sawdust, it is not surprising that many went up in smoke. (Courtesy ICHM.)

This lumber camp, seen about 1900, was located in Kimball in Iron County. In the upper part of the photograph, previously scrawny, sun-starved trees are out in the open. These are the unused trees. But what happened to all the leftovers from milling? In some cases, sawdust and chunks of wood went into streams, altering the river bank; other times, sawdust was used to cover the muddy streets. Sawdust streets could start a fire. Just four years after this photograph was taken, Kimball's streets were aflame. (Courtesy ICHM.)

This mill produced shingles, some of which are bundled on the left of the image. (Courtesy ICHM.)

Lumber mills, such as this one in northern Iron County, faded away. But before settlers could try to make money by farming, stumps had to be cleared. Geographer Tim Bawden tells how both the Wisconsin government and the university actively promoted agriculture as a way to increase settlement in the north, even if the area was too poor for farming. In fact, groups of Wisconsin government employees traveled to northern Wisconsin to show people how to pull stumps, in large part due to the government's insistence on increasing settlement in this area. Dynamite was not just needed for the mines; it was also useful for blasting away tree stumps. In his 1958 book *Vein of Iron*, Walter Havighurst notes that Bessemer, like other North Country towns, enacted laws against smoking on the dynamite wagon, perhaps as a result of explosions. (Courtesy ICHM.)

Similar to elsewhere in the Northwoods "cut-over" region, almost all of the Gogebic's old-growth trees were chopped down during the late 1800s and early 1900s. In a scant few places, trees were kept. As part of their job, lumberjacks took the tree trunk and left behind dead branches, leaves, and sawdust. These leftovers easily started scorching fires. (Courtesy IAHS.)

After logging came through the Gogebic Range, much of the land was sold for farming, tree stumps and all. The region bears rocky, thin soils with a short growing season, especially away from Lake Superior. In a few cases, farms continue to the present day, but most went bankrupt during the Depression. (Courtesy LC.)

Between the Gogebic Range and Lake Superior, soils can hold more moisture. Moderation from Lake Superior also extends the growing season slightly, making a few varieties of farming possible. Hay fields, dairy operations, and a couple of berry farms can be found north of the range, particularly in northern Iron County. Each type of farm required specialized types of buildings, of course. But a farmer's ethnicity also influenced the arrangement of farm buildings. Immigrant farmers often built barns, sheds, and other storage areas in an arrangement similar to their parents' farms back in Europe. (Courtesy IAHS.)

During the Gogebic's formative years, Finnish miners often hoped to quit their jobs in the mines and start a farm. Even though farming these thin, rocky soils was tough, the less-regulated agrarian life was more lucrative than mining, especially to the Finns, who had led farming lifestyles back in Europe. (Courtesy IAHS.)

Several fallen birches stretch along Lake Superior's shore in the aftermath of a nasty storm. Large chunks of wood along Superior's shore are nothing new. The area's famous storms regularly wash up trees and agates, popular stones for rock hunters. (Courtesy IAHS, Ray Maurin Collection.)

The ever-popular waterfalls were frequently featured on late-1800s and early-1900s Gogebic Range postcards, such as this 1908 scene on the Black River near Bessemer. (Courtesy IAHS.)

A teenager rides a cable across the Black River in November 1917. The cables probably started and ended at sturdy trees on each shore. Given the frigid water temperature in November, the teenager would be in trouble if he fell down into the water. (Courtesy IAHS.)

In 1938, United States Forest Service architect Oakie Johnson designed a suspension bridge extending across the lower reaches of the Black River. The Works Progress Administration and Civilian Conservation Corps cooperated to build the span during the middle of winter in 1938–1939. Wood for the construction was cut from nearby trees using an on-site sawmill. This bridge was rebuilt three decades later. (Courtesy IAHS.)

Seven

RECREATION

Late-19th-century newspaper articles mentioned leisure activities such as social dances, cooking demonstrations, and boxing matches. On holidays, employees from various mines would form impromptu teams and challenge employees of other mines in friendly competition. These games included popular sports such as baseball and obscure contests such as seeing which team could drill through rock faster. And in these rough-and-tumble mining towns, taverns and nightlife have always been popular sources of entertainment.

As mines closed up, and with the economy depressed, the region attempted to change its identity from that of a mining region to "Big Snow Country." Ski hills were developed, and the Copper Peak ski jump brought attention to the area. But skiing has an older history here. Nearly 100 years ago, a ski jump existed at Curry Hill in Ironwood. Additionally, in the early 1900s, before modern snow-plowing equipment, the wintry streets of range towns made travel difficult; some residents would use skis for transportation.

The Gogebic's physical geography makes for great outdoor recreation. The Ottawa National Forest now encompasses the Gogebic's eastern end. However, ever since the Milwaukee, Lakeshore, and Western Railroad came to the range, moderate degrees of tourism have occurred. The Milwaukee, Lakeshore, and Western published brochures promoting a few stops along its route, since tourists visiting these places usually took the train. In doing so, the company brought attention to Lake Gogebic, Upper Michigan's largest, as a place for fishing. Tourists from Milwaukee or Chicago, for example, could ride the train to Gogebic Station, at which point a carriage ride would deliver them to fishing resorts on Lake Gogebic. This tourism was also tied into the prevailing idea that certain landscapes were naturally healthy.

In the northern Wisconsin and Upper Peninsula tourism industries, locations near water have historically fared better than places farther away. While the Gogebic has fewer lakes than Wisconsin's Northwoods Lake District farther to the south, the range has always attracted waterfall seekers.

Montreal's amenities included a skating rink nestled amidst its white houses, as shown in this mid-1930s photograph. Given the sometimes violent nature of hockey, it was useful that the company clinic stood adjacent to the rink, located on the right side of this view. (Courtesy ICHM.)

Unlike other sports uniforms, early-19th-century hockey jerseys were usually thick wool sweaters. Players' gloves and goaltenders' protective equipment had brown leather exteriors padded with deer hair. In these days, goaltenders did not wear masks; the goalie on the left only had a woolen baseball-style cap to protect him. (Courtesy IAHS.)

Rough-and-tumble mining towns had equally rugged forms of amusement. Drinking, gambling, and the frequenting of brothels garnered attention from print media elsewhere. Late-1800s newspaper editors lamented fights occurring in the streets, but this wrestling match had been pre-planned. A jagged wooden fence rises behind the spectators; these towns were developed in a hurry, a fact reflected in 1880s cultural landscapes. (Courtesy IAHS.)

Similar to most other places within frontier regions, attendees at this wrestling match display stark gender divisions. On the Gogebic, the ratio of women to men would not equalize until around 1920. (Courtesy IAHS.)

During the mid-1890s, the Twin City Whist Club was comprised of civic leaders. Social elites had different forms of recreation than miners did, though both groups used spittoons. (Courtesy IAHS, Wilbur Bridgman Collection.)

This angle of the Curry Hill ski jump shows the structural design used to support the weight of the jump. The scaffolding blew over during a storm in 1930. A new ski jump was built elsewhere in 1936. (Courtesy IAHS.)

The Curry Hill ski slide is pictured in 1911. Although the region placed a greater emphasis on downhill skiing after its mines closed, the sport has had a long tradition in the Northland. (Courtesy IAHS.)

This view was taken from the top of Curry Hill during a ski-jumping competition. The Gogebic hosted the United States Ski Jumping Championship in 1913. The world record for distance jumped was broken during the competition when Ragnar Omtvedt of Chicago flew 169 feet. Two years later in Colorado, Omtvedt broke his own record set in Ironwood. (Courtesy IAHS.)

Looking downhill, this view shows the Mt. Zion ski area on a sunny winter day in the late 1930s. (Courtesy IAHS.)

After mining activities caused parts of range towns to subside, a few creative ideas were used with this space. One example was the ski slide at the East Norrie subsidence area. (Courtesy IAHS, Ray Maurin Collection.)

Here, an athlete glides upon landing in front of a vast audience. Way before the construction of Copper Peak, ski-jumping competitions proved popular in this hilly region of long winters. (Courtesy IAHS.)

A Packard automobile rests on the beach at Saxon Harbor. Note the parallel arrangement of the driftwood beneath the car. To ensure that the Packard would not get stuck, its owners found and lined up the driftwood. No wood has been placed in front, so they likely had no intention of driving any farther. Perhaps this photograph was a way for the family to portray their level of social class by posing on the beach during an era in which cars were a luxury. (Courtesy IAHS.)

Winding its way over conglomerate stone, Gorge Falls is one of several scenic waterfalls on the Black River north of Bessemer. Although old-growth forests are few and far between, areas of steep slope alongside the lower portions of the Montreal, Black, and Presque Isle Rivers made cutting unsafe, so these are great places to find remnants of old growth.

Since its inception in 1945, Porcupine Mountains State Park has been the Midwest's largest wilderness area. On the way to Lake of the Clouds, the drive along Lake Superior is memorable. Tourists visiting the Gogebic often drive to the nearby Porcupine Mountains. The road shown above extends between Lake of the Clouds and the park's eastern end. Several groups had advocated expanding the road westward along the coast through to the far western end of the park, but others feared environmental damage. Proposals to develop the south shore of Lake Superior were taken seriously during the mid–20th century, when some civic leaders believed that opening a lakeshore road would increase tourism. In 1963, the Gogebic County Planning Commission advocated creating a coastal road between Little Girl's Point east to Black River Harbor and on to the west side of the Porcupine Mountains. These proposals have not yet been implemented.

In the vicinity of the Gogebic Range, Lake Superior's shores display a variety of geological formations. Near the mouth of the Montreal River, sandstone bluffs meet the lake. Near the west end of the Porcupine Mountains, sandstone and shale ledges brush up against the water. Elsewhere, erosive red clay bluffs are eaten away by wind and water. But historically, the shoreline is busiest at sites with a sandy beach. The sands of Saxon Harbor, Little Girls Point, and Black River Harbor lure locals and tourists alike. (Courtesy IAHS.)

Lake Gogebic, Upper Michigan's largest inland lake, has been a hotbed for tourism since the 1880s. This late-19th-century photograph shows a steamboat on the lake. (Courtesy LC.)

Since human settlement, waterfalls have attracted people's attention and imagination. Travel brochures from the 1800s referred to them as magical. People tend to see waterfalls as natural phenomena, but other civilizations understood them in cultural terms. To the Ojibwe, waterfalls were spirits. (Courtesy IAHS.)

At the west end of the range, Wisconsin's Copper Falls State Park is a magnet for silent sports enthusiasts. Here, Brownstone Falls flows over ancient lava rock in the 1930s. Some mid-20th-century postcards depict a suspension footbridge above the falls.

The 80-foot-high Plummer Mine headframe is the last remaining of a once-common Gogebic landscape feature. It is located just off of Highway 77 near Pence, Wisconsin.

Epilogue

Reputations die hard. The last Gogebic mine closed four decades ago. Nonetheless, the mining identity lives on, imbued in the people. The images and lore of the mining past remain as an indelible mark on the region's cultural memory and reputation. This sense of place continues as elements of the mining landscape fade away: Most of the scenes in this book no longer exist. As time passes, trees have begun to grow on tailings piles, obscuring the piles of waste rock. Nature gradually conceals the land's scars. Mine buildings have been destroyed. Headframes have been torn down. Luckily, the Plummer Mine headframe still stands, the last on the Gogebic.

Many of the memories linger. Memory is reflected in the landscape through historic preservation, monuments, and plaques. Street names also reflect the area's mining heritage. These memories alone, though comforting, do not bring jobs. If there was an easy answer to fixing the Gogebic's economy, somebody would have likely implemented it already. As we saw when the mines closed, reliance on one main economic staple is dangerous for a community. Historic preservation allows the retention of the region's distinctiveness while bolstering the economy. The Gogebic Range does showcase its distinctive history and geography. More could be done, however, to retain this strong sense of place. For example, the Plummer Mine headframe site should be further developed as a wayside along Highway 77.

The Gogebic has a strong heritage, which can be promoted more. Through historic preservation—which is easier said than done—we can ensure that future generations will be able to learn the stories of its landscapes.

BIBLIOGRAPHY

Alanen, Arnold. "Home on the Range: Settling the Penokee-Gogebic Iron Ore District of Northern Wisconsin." *Wisconsin Land and Life.* R. Ostergren and T. Vale, eds. Madison, WI: University of Wisconsin Press, 1997.

Aldrich, Henry R. *Geology of the Gogebic Iron Range of Wisconsin.* Madison, WI: Wisconsin Geological and Natural History Survey, 1929.

Bawden, Timothy. "Reinventing the Frontier: Tourism, Nature, and Environmental Change in Northern Wisconsin, 1880–1930." (Ph.D. diss., University of Wisconsin–Madison, 2001.)

Chew, Margaret Sarah. "The Geography of the Gogebic Range Area in Iron County, Wisconsin." (Unpublished M.S. thesis, Northwestern University, 1936.)

Cox, Bruce. *Iron Fever: How Two Irishmen and a Yankee Started the Gogebic Iron Range.* Wakefield, MI: Agogeebic Press, 2005.

Cronon, William. *Nature's Metropolis: Chicago and the Great West.* New York: W. W. Norton, 1991.

Dott, Robert H. and John W. Attig. *Roadside Geology of Wisconsin.* Missoula, MT: Mountain Press Publishing Company, 2004.

Eckrose, Roy. "The Gogebic Iron Range." (Unpublished M.A. thesis, Western Illinois University, 1979.)

Francaviglia, Richard V. *Hard Places: Reading the Landscape of America's Historic Mining Districts.* Iowa City, IA: University of Iowa Press, 1991.

Gogebic County Board of Supervisors. Department of State Bureau of History, State Archives of Michigan. RG 90–183, Box 1, Volume 54.

Gogebic County Planning Commission. *A Continuing Program for Economic and Physical Planning and Development: Gogebic County, Michigan.* Ironwood, MI: Gogebic County Planning Commission, 1963.

Gogebic Range Mining and Business Directory. Wakefield, MI: Northern Directory Company, 1888.

Havighurst, Walter. *Vein of Iron: The Pickands Mather Story.* Cleveland, OH: World Publishing Company, 1958.

---. *The Great Lakes Reader.* New York: Macmillan Publishing Company, 1966.

Lemmer, Victor F. *History of Gogebic County, Michigan.* 1954.

Liesch, Matthew. "Early Days on the Gogebic Iron Range: Reputation, Riches and Rowdiness." (Unpublished M.S. thesis, University of Wisconsin–Madison, 2006.)

Martin, John Bartlow. *Call it North Country: The Story of Upper Michigan.* New York: Alfred A. Knopf, 1944.

Meinig, Donald W. *The Shaping of America: Transcontinental America 1859–1915.* Volume 3. New Haven, CT: Yale University Press, 1998.

Norris, Wellge, and Company. *Bessemer, Mich., Ontonagon County 1886.* Milwaukee, WI: Beck and Pauli, 1886.

———. *Hurley, Wis., Ashland County 1886.* Milwaukee, WI: Beck and Pauli, 1886.

———. *Ironwood, Mich., Ontonagon County 1886.* Milwaukee, WI: Beck and Pauli, 1886.

Olmanson, Eric D. "Romantics, Scientists, Boosters, and the Making of the Chequamegon Bay Region on the South Shore of Lake Superior, 1820–1900s." (Ph.D. diss., University of Wisconsin–Madison, 2000.)

Proctor, Dean Wade, Fahriye Sancar, and Arnold Alanen. *Preservation and Planning on the Gogebic Iron Range of Wisconsin and Michigan: A Report on the Historic Resources Workshops, September–November 1988, Hurley, Wisconsin.* Madison, WI: School of Natural Resources, College of Agricultural and Life Sciences, University of Wisconsin–Madison, 1989.

Pyle, Susan Newhof, ed. *A Most Superior Land: Life in the Upper Peninsula of Michigan.* Lansing, MI: Michigan Natural Resources, 1983.

Reimann, Lewis. *Hurley–Still No Angel.* Ann Arbor, MI: Northwoods Publishers, 1954.

Reps, John. *Bird's Eye Views: Historic Lithographs of North American Cities.* New York: Princeton Architectural Press, 1998.

Techtmann, Catherine. *Rooted in Resources: Iron County, Wisconsin 1893–1993.* Friendship, WI: New Past Press, 1993.

Wackman, John F. *A Historical and Archaeological Reconnaissance of the Saxon Harbor Area, Iron County, Wisconsin.* Waukesha, WI: Great Lakes Archaeological Research Center, 1979.

Wheeler, Edgar C. "Cave-In!" *Popular Science Monthly.* December 1926.

Whitcomb, H. F. and Charles McKinlay. *Gogebic, Eagle River, Ashland, and Other Resorts in Northern Michigan and Wisconsin Reached by the Milwaukee, Lake Shore, and Western Railway.* Chicago: Poole Brothers Printers and Engravers, 1886.

Wisconsin Heritage Areas Program. *Heritage Areas of Iron County.* Madison, WI: Department of Landscape Architecture, University of Wisconsin–Madison, 1977.

Zelinsky, Wilbur. "North America's Vernacular Regions." *Annals of the Association of American Geographers* 70 (1980): 11–14.

Across America, People are Discovering Something Wonderful. Their Heritage.

Arcadia Publishing is the leading local history publisher in the United States. With more than 3,000 titles in print and hundreds of new titles released every year, Arcadia has extensive specialized experience chronicling the history of communities and celebrating America's hidden stories, bringing to life the people, places, and events from the past. To discover the history of other communities across the nation, please visit:

www.arcadiapublishing.com

Customized search tools allow you to find regional history books about the town where you grew up, the cities where your friends and family live, the town where your parents met, or even that retirement spot you've been dreaming about.